THE LURE OF
AND THE CULT OF

*The Kunstkammer and the Evolution
of Nature, Art and Technology*

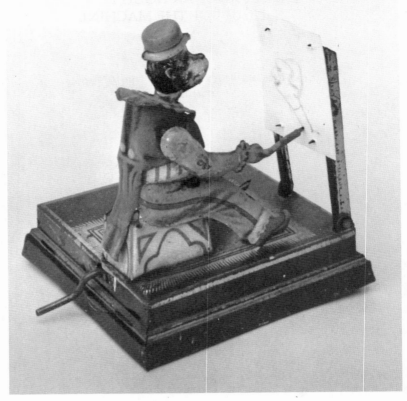

Automaton of a monkey that can draw
1895, Strasbourg, Musée Historique

THE LURE OF ANTIQUITY AND THE CULT OF THE MACHINE

The Kunstkammer and the Evolution of Nature, Art and Technology

HORST BREDEKAMP

Translation from German
by Allison Brown

 Markus Wiener Publishers
Princeton

THE TRANSLATION OF THIS BOOK INTO ENGLISH WAS SUPPORTED
BY A GRANT FROM INTERNATIONES, BONN.

FOR INFORMATION WRITE TO:
MARKUS WIENER PUBLISHERS
114 JEFFERSON ROAD, PRINCETON, NJ 08540

LIBRARY OF CONGRESS CATALOGING-IN-PUBLICATION DATA

BREDEKAMP, HORST, 1947–
[ANTIKENSEHNSUCHT UND MASCHINENGLAUBEN. ENGLISH]
THE LURE OF ANTIQUITY AND THE CULT OF THE MACHINE: THE KUNSTKAMMER
AND THE EVOLUTION OF NATURE, ART, AND TECHNOLOGY/HORST BREDEKAMP;
TRANSLATION BY ALLISON BROWN.
INCLUDES BIBLIOGRAPHICAL REFERENCES AND INDEX.
ISBN 1-55876-093-8 (HC) ISBN 1-55876-094-6 (PB)
1. ART MUSEUMS—EUROPE—HISTORY—17TH CENTURY.
2. ART MUSEUMS—EUROPE—HISTORY—18TH CENTURY
3. ART AND TECHNOLOGY—EUROPE.
I. TITLE.
N1010.B7413 1995
708.94—DC20 95-16753 CIP

COVER DESIGN BY CHERYL MIRKIN
THIS BOOK HAS BEEN COMPOSED IN PALATINO BY CMF GRAPHIC DESIGN

MARKUS WIENER PUBLISHERS BOOKS ARE PRINTED ON ACID-FREE PAPER,
AND MEET THE GUIDELINES FOR PERMANENCE AND DURABILITY
OF THE COMMITTEE ON PRODUCTION GUIDELINES
FOR BOOK LONGEVITY OF THE COUNCIL ON LIBRARY RESOURCES

PRINTED IN THE UNITED STATES OF AMERICA

Contents

Preface to the American edition

After I completed the text for the German edition in 1992, a host of new works on the *Kunstkammer* appeared. An excellent survey is provided in the anthology *Macrocosmos in Microcosmo. Die Welt in der Stube. Zur Geschichte des Sammelns 1450 bis 1800*, Andreas Grote, ed., Opladen 1994. Since questions raised in this essay have not been touched upon by more recent literature, the English language edition remained essentially the same as the German original.

I would like to thank Allison Brown not only for the translation, which if translated back into German would prove far more comprehensible than my German text, but also for the numerous philological references that have improved the book as a whole.

Preface to the German edition

When I was asked to prepare my ten-year-old essay on the theory of the Kunstkammer to be reprinted for the "Kleine kulturwissenschaftliche Bibliothek," only a few cosmetic changes and a brief updating was intended. The text had received the Aby Warburg Prize of the city of Hamburg and was supposed to retain its original form.* The wealth of newly researched materials on the history of collections, a series of changing hypotheses, and most of all changes in the present-day understanding of images and art led to the decision to rewrite the text totally. In the end, hardly anything has remained of the original work other than the main title and the short, final sentence of the main section.

First and foremost, I would like to express my thanks to the Wissenschaftskolleg zu Berlin. As a fellow there in 1991-92 I had the opportunity to prepare the text. Silvia Baumgart, Hartmut Böhme, Heike Hardt, Thomas Ketelsen, Wolfgang Krohn, and Martin Warnke receive my thanks for their critical reading of the manuscript, and Marita Bermes, David Freedberg, Thomas Fusenig, Stephen Holmes, and Patrizia Pinotti for their important comments.

H.B., 1993

* ———, "Antikensehnsucht und Maschinenglauben," in Herbert Beck and Peter Bol, eds., Forschungen zur Villa Albani. Antike Kunst und die Epoche der Aufklärung (Berlin 1982): 507-559.

Translator's Note

In view of the range of literature referred to in the text, it has not proved possible in every single case to undertake the bibliographic task of tracing English translations of works originating in other languages and locating the passages quoted, although every possible effort was made where this was feasible. Where no English source could be located, the author's references to German works and German translations of works written in Latin or other languages have been retained. As far as possible, English language editions of works originally written in that language, and English language translations of works written in other languages have been cited.

I would like to acknowledge John Broadwin for his assistance in the translation of the first two chapters.

ALLISON BROWN

Introduction

Horst Bredekamp teaches the History of Art at the Humboldt University in Berlin and has written a number of books on the artistic and cultural history of early modern Europe. His massive study of the most elaborate of Italian Renaissance gardens, Bomarzo, and its strange creator, Vicino Orsini, is a model art-historical monograph, elaborately documented and meticulously argued. But he has also produced a lively essay on the social and cultural origins of Florentine football and a cogent, absorbing effort to decode Botticelli's eternally provocative *Primavera*. All of these studies reveal a highly individual point of view, one that has enabled Bredekamp to reframe even the oldest problems and questions in a way at once original and convincing. All of them offer both formal analysis of works of art and reconstructions of the larger historical contexts in which these were produced. All of them, finally, attest to their author's consistent effort to combine erudite and philosophical approaches to the past: to mine the sources and to ask new theoretical questions of them at the same time. This example eminently deserves study and emulation in the English-speaking world.

In the present book-length essay, Bredekamp performs what the German art historian Aby Warburg defined long ago as a central task of cultural history: he forces his way past the "border police" who normally keep each scholarly discipline distinct from the rest, and shows that modern ways of organizing knowledge do not and cannot do justice to vital aspects of social and cultural history. Traditionally, in Europe and America, art historians have concerned themselves with images, historians with texts. Historians of the classical tradition traced the afterlife of classical texts and images; historians of the Scientific Revolution, by contrast, tried to explain the

birth of what was taken as the essential new idea that human knowledge could change and improve on nature. Almost no one except specialists tracing the pedigree of a particular painting or a sculpture took much interest in the great collections of natural and human objects, known as *Kunst- und Wunderkammern,* in which intellectuals like Athanasius Kircher and Ole Worm and collectors like the Holy Roman Emperor Rudolf II organized narwhal horns and fossils, paintings and crystals, books and manuscripts, obtained at vast expense and displayed with great ingenuity, in elaborate, now mysterious systems.

Over a decade ago, Bredekamp showed in the prize essay which forms the core of this book that the *Kunst- und Wunderkammer* was in fact something more than a collection of splendid works of art and nature. It was the alembic in which a new view of nature took shape—one which showed, visually and vividly, that nature and art had histories, and emphasized the radical changes that nature underwent over time as its powers and resources were exploited in novel ways. The ingredients that came together in this new space were often traditional, even classical: but they took on different visual and verbal forms, so compelling that they in turn inspired Bacon and Kepler, Descartes and Locke. Bredekamp combines analysis of images with interpretation of texts, re-creation of the actual space in which collectors arranged and contemplated their booty with historical reflection. It becomes clear that the *Kunstkammer* characterized a particular, identifiable moment in early modern intellectual and cultural history—and one of a fertility and tension that most earlier historians had quite failed to grasp. In this enchanted garden of acquisitiveness and curiosity, humanistic expertise in the analysis of texts and artisanal knowledge of how to work natural materials, the desire to enhance imperial or royal prestige and the will to enlarge the sphere of human activity, the nostalgia for the perfection of a classical past and the desire for the power of a scientific future all fitted together as organic parts of one sensibility and one

enterprise. Ancient sculpture and modern automata seem an odd couple: Bredekamp, however, shows how both could be seen as exemplifying the same coherent history of nature and man's dealings with it.

The result is a challenging, provocative essay in cultural history. It offers a new account of the development of aesthetics and natural history in the sixteenth to eighteenth centuries. It raises new questions about the cultural history we are now making. And it shows that even the most sensitive and erudite cultural historians have gone wrong because they have treated visual documents as illustrations of doctrines stated more clearly in verbal ones, rather than as independent evidence for the history of ideas about nature. Historians of science and literature as well as art historians will find much of interest in Bredekamp's book.

Anthony T. Grafton
Princeton, July 1995

THE QUESTION OF MOVEMENT

Sculpture and Machine

One of the most trying moments in Benvenuto Cellini's life, which surely was not in want of problems, came in January 1545 in the gallery of the palace at Fontainebleau. Cellini had been commissioned to create a series of silver statues for François I of France. Of the required series, only a single sculpture of Jupiter had been completed. In order to conceal this omission and confront the resentment of the powerful Madame d'Estampes, he attempted to enhance the value of his silver figure by employing unusual means. He was able to attain an initial advantage since Madame d'Estampes had delayed the King's visit until dusk, so that his work "would appear less beautiful due to the darkness. But as God has promised those trusting in Him, what came to be was just the opposite of that which she had planned. As night approached, I lighted the candle in Jupiter's hand. Since he was holding it a bit above his head, the light shone down from above, making the figure look far more beautiful than it would have in daylight."

The effect was also enhanced by the fact that Cellini had placed the silver statue on a golden plinth connected to a barely visible wooden block: "I had placed four small hardwood balls inside the wooden block, so that more than half of each ball was concealed. The balls were the size of those hurled from a sling and everything was arranged so skillfully that even a small child could move the Jupiter back and forth or from side to side without expending any effort whatsoever." When the King finally entered the gallery with his entourage, "I had my assistant Ascanio slide the beautiful Jupiter forward ever so gently, and because I had constructed the device that enabled this motion quite ingeniously, that slight movement of

1

the statue made it appear alive. All eyes abandoned the ancient art in the room, turning immediately and with great pleasure to my work." Madame d'Estampes tried to detract from the impact by commenting on the unparalleled quality of the sculpture of antiquity, but the King's judgment was unwavering. "Whoever wished to disadvantage this man has done him a great service; for these splendid figures provide visible proof that his work is much more beautiful and wonderful. High praise is thus accorded our Benvenuto; his works do not merely rival those of the ancients, but surpass them." The message was clear. The mechanical impetus brought the sculpture to life and helped its creator to triumph—modern art in the form of a "machina" had outshone the magnificence of antiquity.[1]

The conflict between the mobile modern statue and its static ancient counterpart might seem like an early stage of the automatic mechanical motion which reached its agogee in the machines of the 18th century. Even a mere glance, however, shows that the relationship between modern machines and ancient sculpture was by no means a one-way street and that the incident in Fontainebleau attests a value hierarchy which could just as easily have been reversed.

"La charmante catin" (fig. 1), a youthful work of French illustrator and copperplate engraver Charles-Nicolas Cochin from the year 1731, seems to verify Cellini's manipulation and the effects it produced. It depicts a group comprised mainly of women gathered in a drawing room around a doll illuminated by candles. The doll has an internal clockwork mechanism enabling it to move like a machine.

> Sans badiner, mais ce que nous sommes,
> Telles est souvent notre destin.
> Les Grands, quand il leur plaît,
> font a peu près des hommes
> Ce qu'un ressort caché fait icy de Catin.[2]

2

Without jest – but that which we are
is often our fate.
The great ones, if they so desire,
almost make of the people
that which a hidden spring makes here of the courtesan.

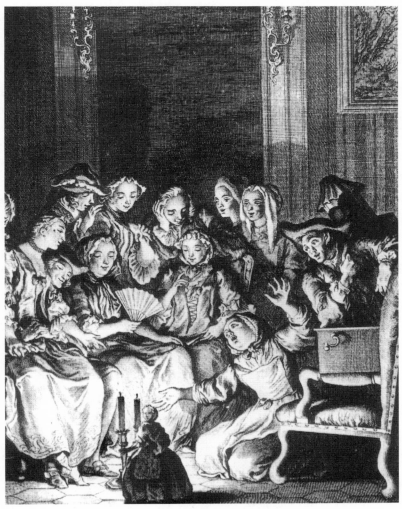

Fig. 1: La charmante catin,
Copper engraving by Charles-Nicolas Cochin, 1731
Paris, National Library

By equating the doll and "Catin" (courtesan), the text makes ironical reference to the corruptibility and hidden manipulation of seemingly free, autonomous movement. The illustration is not impressive as a pure rendering of this somewhat naive moral truth, but rather in terms of the manner in which the machine departs from the moralizing level. Cochin put all his verve into the illusionary impact of independent movement. The doll, bathed in a diffuse and flickering light, dominates the scene with the power of a supernatural apparition. Facing the magic of this autonomous movement, the plainly-dressed woman in the foreground falls to her knees in a praying gesture and the other, more reserved witnesses also seem deeply affected.

A few years after Cochin's engraving was completed (1738-39), Jacques de Vaucanson constructed a trio of automatons—a flute player, a drummer, and a duck—prompting Voltaire to write that "the daring Vaucanson, rival of Prometheus, / imitating the forces of nature, / seemed to steal fire from heaven to bring his figures to life."[3] In 1748, the physician Julien Offray de La Mettrie maintained that in light of advances made in automaton production, exemplified so admirably by Vaucanson, it was only a matter of time until some particularly deft mechanic would succeed in constructing a synthetic human being.[4] By the 1770s his prediction seemed to have come true with the building of similar yet more complex figures capable of such activities as playing the piano, painting, or writing. Like a child learning to write, an automaton designed by Pierre Jaquet-Droz predicted the coming of age of this type of figure, by writing sentences such as "We are the androids" and "Cogito, ergo sum"[5] (fig. 2). A new era in the evolution of creation appeared to be dawning, relegating to the past everything that had been created up to that point.

The fact that this admiration for androids did not diminish respect for ancient sculpture seems all the more surprising. Collections of ancient art were being established or reorga-

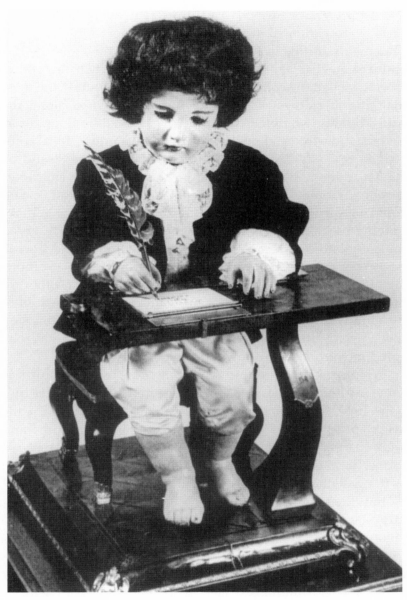

*Fig. 2: Writing automaton by Pierre Jaquet-Droz and Jean-Frédéric Leschot,
1773, Neuchâtel (Switz.), Musée d'Art et d'Histoire*

nized throughout Europe. And if originals were unavailable, casts were exhibited (in Göttingen starting in 1767 and in Mannheim starting in 1769) that were received with hardly less enthusiasm than the originals themselves.[6] When the young Goethe visited the collection in Mannheim, he found "the most magnificent statues of antiquity not only aligned along the walls, but also scattered randomly over the entire floor: a forest of statues to wend one's way through, a grand, ideal community to push through. All these splendid statues could be shown in the best possible light by the opening or closing of curtains; moreover, they had been placed on pedestals and could be turned and moved according to one's liking."[7] Yet nothing seemed to parallel the high regard that was reserved for automatons; the mesmerizing illumination in the Cochin engraving had given way in Goethe's description to appropriate, aesthetic lighting and the statues were moved about by means of external mechanisms. Instead of creating the aura of future beings that owed their creation to man, the impression they gave of life resembled more a lofty, past form[8] that relegated modern man to a lower order of being.

Whereas Goethe seemed to regard ancient sculpture as some unattainable standard set in the remote past, La Mettrie's hope for the merging of man and machine opened up the bright prospect of a new stage in creation. Sculptures and androids represented not only fundamentally different art forms, they also exemplified objectives so incredibly divergent, as if a vast chasm lay between them.

But Étienne Bonnot de Condillac's *Traité des sensations*, published in 1754, offered at least a hint of a bridge. The protagonist in his treatise is a "statue" that is cut off from its environment by its cold marble skin. Devoid of memory and experience and with an empty brain, the statue possesses neither knowledge nor moral concepts; when endowed with sensory perception, in particular the sense of touch, however, it begins to acquire a soul. Like a sculptor who gives form to raw materials, human beings—like the marble statue—give themselves

form: "Experience and reflection are to them what the chisel is in the hands of the sculptor who carves a perfect statue out of a block of stone; the skill with which they manipulate the chisel will be the measure of the new knowledge and joy that emerges from their sensations."[9]

By absorbing and reflecting on sensory impressions, Condillac's statue—the embodiment of the *tabula rasa*—becomes a human being with a soul. This deals with more than the ancient myth of Pygmalion, where a "cold" statue is brought to life; it is about giving life to mechanical beings who are capable of learning on their own through independent movement.[10] The statue combines movement and its marble exterior, bringing together various aspects of art and mechanics, antiquity and the machine age.

Occupying an intermediate position between sculpture and machine, Condillac's statue can be regarded as a recurrent theme. Though diametrically opposed to one another, androids and ancient statues shared the fact that both existed within the realm lying between the natural state and human creativity and were considered expressions of an effort to use the shaping of natural materials to explain the relationship between human beings and their natural surroundings. Interest in them and in their history was stimulated largely by speculative curiosity about how to determine the relationship between nature and products of human skill.

Natural History Void of Time

In contrast to the modern view of natural history, the concept of *naturalis historia* advanced by Pliny the Elder embraced the description of the given state of natural things or species, rather than their evolution. This view of natural history generated a two-dimensional description of things as they existed and not a conception of developments over time. In accordance

7

Church - unchanged; no history.

with the original meaning of the word *"historia"* as an account of individual events and occurrences of the past, descriptive natural "history" precluded any attempt at historicizing the natural world, instead solely describing the natural objects, their properties, and uses. This approach was extoled by the Church, since such a limited concept of "history" corresponded with Biblical chronology, according to which the world was created in six days, and from the seventh day onward, the fundamental structure of natural materials or species remained unchanged. Nature thus had a definite physiognomy void of history.

Descriptive + Historical

Immanuel Kant's division of *naturalis historia* into descriptive and historical components, which he undertook in 1775, is considered a milestone in the revision of this concept.[11] "We generally take the terms **nature study** (*Naturbeschreibung)* and **natural history** (*Naturgeschichte)* to mean one and the same thing. It is obvious, however, that a knowledge of the things of nature as they **now are** leaves a great deal to be learned about what they **once were**, and what changes they underwent in arriving at the point where they are now and in their present state." This led to the need to historicize natural history: "Natural history—which is virtually non-existent in a historical form—would teach us about changes in the structure of the earth and the terrestrial creatures (plants and animals) over the course of their natural migrations and about the ensuing mutations from the prototypes of species."[12] Though the idea of expanding the notion of natural history to cover periods of *time*—as distinct from classical descriptions of nature limited to a particular *space*—seemed radical at the time, it was hardly new. It actually derived from visual observations that had been made with respect to the collections of the *Kunstkammer* for more than 200 years. Both automatons and ancient sculpture played a crucial role in this regard, for at these focal points where the creations of man and of nature merged and clashed, a more dynamic view of nature was born. The process, based on pure observation, took its own course, culminating in the

historical development of natural history.

However, given their somewhat suggestive name—"Cabinets of Art and Curiosities"—the *Kunstkammern* seemed to smack of the pre-scientific period and the bizarre, so that despite more recent efforts to restructure the collections, the natural philosophy aspect of their systematic organization was not apparent in the inventories and their underlying philosophies.[13] Having built up an inventory of human technical and artistic skills in two distinct and disparate areas—ancient sculpture and modern machines—these collections gave rise to a kind of dynamic historical reflection that penetrated even into the area of natural history. It is the thesis of this essay that the historicization of nature was already underway within the scope of the *Kunstkammern* from the 16th to the 18th centuries.

THE HISTORICAL CHAIN

Natural Formations and Ancient Sculpture

Ancient sculpture was an explosive subject for natural history of the Renaissance, because the statues of antiquity obscured the distinction between divine, natural creativity and its human counterpart. Categorized as fossils because they, too, derived from the earth, sculpture of antiquity oscillated between being considered a product of nature and a creation of man. Parmigianino's enigmatic "Portrait of a Collector" illustrates the tension between natural and human creativity as the interaction of the three kingdoms of nature (fig. 3). Behind and to the right of the dominant human figure is a depiction of the vegetable kingdom, while on the left a tall rock formation looms as a symbol of the mineral kingdom. A high relief of Mars and Venus with Cupid as the fruit of their love has been carved into the side of the rock. The formation extends to the base of the sculpture and gives the appearance of a pedimental relief, so that the figures act as a gabled frieze linking the bare rock to the carving. The figures emerge from the natural stone without having completely left the mineral kingdom. The strangely ambivalent, restless look of the figures is intensified by the light of an early dawn rising between the rock and plants, causing Mars, who is bent forward slightly, to exhibit the same eerie hint of life as that which nourished the automaton in the Cochin engraving (fig. 1).[14]

The human figure dominates the foreground as the jewel of nature's third kingdom, the animal kingdom. In his left hand he holds a book, though it is not clear whether this is itself a collector's item or an attempt to symbolize the spirit of humanism that inspired the act of collecting. The objects spread out on the table—some unidentifiable medallions, an obviously ancient coin, and a statuette of Venus—identify the young man

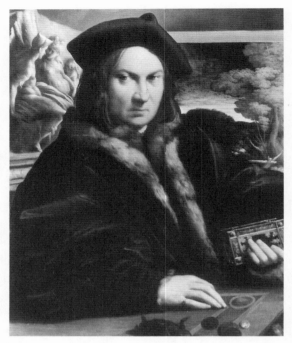

Fig. 3: Portrait of a Collector, Il Parmigianino, ca. 1523,
London, National Gallery

as a collector of mostly ancient artifacts. The light illuminating the vegetation provides a connection to the creations of nature and, ultimately, to freely available works of art; coming from the side, the rays of light strike the objects on display as well as the collector, who is both beneficiary and master of a creative power originating in nature.

The common ground implied here between the art collector and the naturalist lay in the fact that their philosophies agreed on a number of essential points. The idea that works of art, in particular the art of anquity, could mediate between human beings and nature was a basic tenet of both the natural sciences and aesthetics. Bolognese scholar Ulisse Aldrovandi, for example, in his natural history treatise—it is worth noting that he was the first to produce a systematic catalogue of the ancient

Fig. 4: Chance images in marble,
Illustration in: Ulisse Aldrovandi,
Musaeum Metallicum, 1648

works of art collected in Rome[15]—cited not only the nature, appearance, condition, and location of objects, but their usefulness, their significance in literature and historical events, and the way in which they were created by human hands and by nature. Thus the history of natural objects was put into a human context. In his posthumously published work *"Musaeum Metallicum"* (1648), Aldrovandi discussed individual objects and materials in terms of their composition as well as their character as works of art and their significance as idols, statues, or coins. In accordance with Parmigianino's painted depiction of natural history, Aldrovandi too assumed that nature was capable of producing works of art. To bolster his hypothesis Aldrovandi illustrated his chapter on marble with images of human beings and animals—such as the "icon" of a

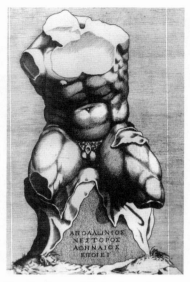

Fig. 5: Bust of Lucretia,
Illustration in: Ulisse Aldrovandi,
Musaeum Metallicum, 1648

Fig. 6: Torso of Belvedere, Copper
engraving by Anton Eisenhoit, ca. 1580
in: Michele Mercati, Metallotheca, 1717

hermit—that were creations of nature alone: *"in Marmore à Natura sculptus"* (fig. 4). He concluded, though, with a series of ancient sculptures representing the synthesis of nature and man, or the links between them (fig. 5).[16]

Michele Mercati, superintendent of the papal botanical gardens under Pius V, produced a striking variation on the same theme. Sometime around 1580 he founded a natural history museum containing objects that had been collected by the Vatican, compiling a catalogue which—although frequently used—was not printed until 1717. Like Aldrovandi he assigned works of art to the respective categories of fossil or other forms of natural material from which they had been made. Works by the Westphalian engraver Anton Eisenhoit that were depicted in the "Marble" chapter include the Laocoön, and the Apollo and the Torso of Belvedere (fig. 6). The front of the statue where the marble has been broken off, exposing the rock's interior with extreme severity, impressively reveals the mineral

14

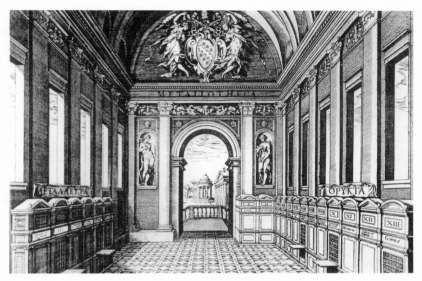

Fig. 7: Museum of Michele Mercati,
Copper engraving by Anton Eisenhoit, ca. 1580,
Frontispiece in: Michele Mercati, Metallotheca, 1717

origins of "classical" art forms.[17] The same is true of the areas
around the base which, in contrast to the severity of the upper
torso, describe a smooth transition from the ground to the
pedestal and the figure.

The depiction of the *"Metallotheca"* conveys the natural and
philosophical background of this arrangement of minerals in
ancient sculpture (fig. 7). The engraving shows the museum,
surmounted by the coat of arms of the Aldrobandini Pope
Clement VII and housed in one of the halls of the Vatican's
Belvedere Palace. In contrast to the accuracy with which the
museum's interior was reproduced, the view through the
window, centered on a round temple inspired by Donato
Bramante's *"Tempietto,"* is a programmatic invention.

The temple is the imaginative reconstruction of an ancient
tract as drawn by Pirro Ligorio—most likely a close acquain-
tance of Mercati—who based the structures on Marcus
Terentius Varro's famous description of his *"Ornithon"* at

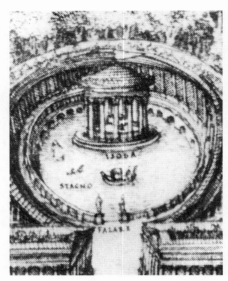

Fig. 8: The aviary of Marcus Terentius Varro,
Drawing by Pirro Ligorio, after 1550,
Turin, Archivio di Stato

Fig. 9: Anton Eisenhoit, Museum of Michele Mercati
[detail of fig. 7]

16

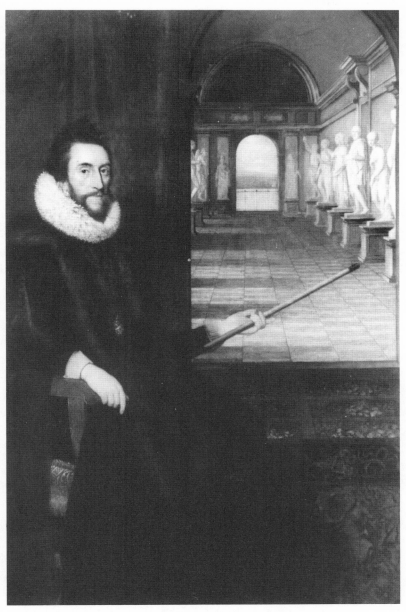

Fig. 10: Portrait of the Earl of Arundel,
Painting by Daniel Mijtens, ca. 1616,
Arundel Castle

Casinum (fig. 8). This detail of the drawing was probably included in the engraving because, like the *"Metallotheca,"* it depicted a naturalist sanctuary with a "museum" in front of it.[18] Mercati transformed Varro's aviary into a mineralogical context by placing a stone statue at the center of the *Tempietto* and making the upper portion of the body the vanishing point of the drawing (fig. 9). The construction of this drawing in strict perspective is not merely a mathematical trick; it also has a "symbolic" function by creating a new, reciprocal perspective on the other side of the vanishing point—a perspective from which the observer can be observed, either by infinity or the eye of God.[19]

Mercati gave this notion a unique twist by placing evidence of man's creativity behind the complete, undamaged temple in the form of ruins that have been reclaimed by nature and returned to their primordial state through a process of erosion. The statue is thus not an end in itself, but a mediating point in the space-time continuum symbolized by the historical realms in the fore- and background. The vanishing point becomes as it were a permeable membrane allowing passage to the universe that predates and is greater than man. Whereas the ruins symbolize the prehistoric powers of nature in opposition to the *"Metallotheca,"* ancient sculpture brings the creations of nature and those of man into balance, heralding the enduring humanization of nature. The statue in the round temple thus provides a twofold link between human creation and natural form. Viewed from the background in the engraving the statue represents nature's vanishing point; however, from the perspective of the museum, the statue is the starting point for human efforts to mold nature.

Daniel Mijten's portrait of Thomas Howard, Earl of Arundel, completed in 1616, offers a comparable retrospective (fig. 10).[20] The earl is seated before a gallery of ancient sculpture. The figures have not been faithfully reproduced, however, but transmuted into ideal images by reflecting aspects of Roman palace architecture. The painting's lines of perspective

converge on the horizon, i.e., on the boundary between the universe and the planet earth, where the movements of earth and the heavens can be most readily observed. As in the case of Parmigianino's work, ancient sculpture forms the hinge that connects the world of the observer to the infinity of nature, anthropomorphizing the material world. The earl's pose also indicates a hidden meaning. Using a pointer, he brings the gallery close to the viewer, though at the same time shifting it into the realm of pictorial imagery, since he appears to be seated near not a room but a painting on the wall. The special feature of such "pictures within a picture" is that the framed picture is given the aura of holy relics preserved in similar fashion.[21]

The question of holy relics also touches on the basic problem of giving a soul or spirit to inanimate matter. What divine healing power is capable of doing for holy relics is accomplished for works of antiquity by the visual arts. Parmigianino's "Portrait of a Collector," Mercati's *"Metallotheca,"* and the portrait of the Earl of Arundel are each comprised of three distinct regions in which natural substances, ancient sculpture, and human beings as collectors successively predominate. Ancient sculpture always acts as an intermediary between matter and human beings, and thus also between prehistory and the present. A series of abstract ideas ranging from the kingdom of nature to the province of man is integrated into a structuring of space, at the same time suggesting a division of history into a chain of successive periods.

The Collector as Prometheus

As early as the 16th century another link was added to this chain. In Jacques Besson's "Theater of Instruments and Machines" (1571-72), one of the most inspired works on mechanics, a visionary illustration shows some ancient relics— an obelisk, a capital, and a column—being pulled out into the

19

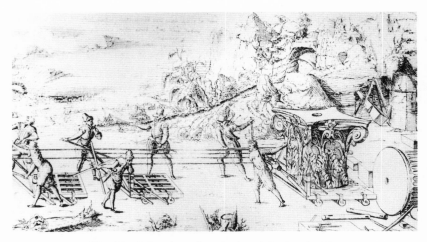

Fig. 11: Salvaging of ancient architectural relics,
Illustration in: Jacques Besson,
Theatrvm Instrvmentorvm et Machinarvm, 1578

open from a hole in a mountain (fig. 11).[22] The size of the massif suggests that nature had seized hold of an enormous edifice. Coming from the opposite direction as in Parmigianino's "Portrait of a Collector," the sun casts its light on nature in the raw as well as on the ancient works of art that have been wrested from it. However, in Besson's illustration, the tools and instruments do not shine any less brilliantly in the sunlight of a new era than the ancient works themselves. The art of antiquity and modern technology each seem to be vaunting their own unique grandeur. As if in some triumphal procession, the various relics of ancient art are brought into the light of a new machine age which, as the inscription indicates, is fully aware that ancient art has bequeathed "enduring beauty to the palaces of the rulers," but that the present day has made an unprecedented mark in history because of the invention of the machine: *"Artificivm nvnqvam visvm."*

The self-assurance that developed soon spread to collectors. Their enthusiasm was further fueled by the connections drawn between the creative powers of Prometheus[23] and the passion

for collecting. Since the time of Pliny, Prometheus had been ascribed the ability to work with nature's hardest and most valuable materials—metals and precious gems—and to teach the practice of wearing rings, the world's first collectibles.[24] Even Schedel's World Chronicle depicted Prometheus in the form of a man regarding a ring[25] (fig. 12). And the Nuremberg merchant Willibald Imhoff, one of the most important collectors of the northern Renaissance, is portrayed without further embellishment in the pose of a man examining a ring, thereby merging the images of the entrepreneur and the collector[26] (fig. 13).

In Italy the qualities of Prometheus as a collector received special emphasis and were inflated for programmatic purposes. Giulio Camillo's theater of all human achievement, as an example of ideal mnemonic construction, can also be understood as an ideal general museum. The arts were depicted at the highest position here, directly below a picture of Prometheus.[27] And in the similar *studiolo* of Francesco I de'Medici in the Palazzo Vecchio in Florence (1569-1575), which encompasses "precious gems, medallions, cut stones, polished crystal, vessels, mechanical inventions and similar things," Vincenzo Borghini, the designer of the collection, topped his hierarchical arrangement of pictures of the gods with an illustration showing Prometheus together with Natura (fig. 14): "Thus Natura is to be painted in the middle of the vault that corresponds to Heaven, her companion being Prometheus, the inventor of precious stones and rings; for as Pliny reports, when Prometheus was chained to a rock in the Caucasus, he made every possible effort, notwithstanding his suffering, to apply himself to his work with diamonds and other precious stones."[28] Finally, Prometheus's rings can also be found on the title page of the catalogue of Mercati's "*Metallotheca*" (fig. 15). Two scholars are carrying on a discussion in front of a statue of Diana of Ephesus that has been placed in a niche framed by columns and molded beams; separating the two is a tablet with the inlaid title of the catalogue.

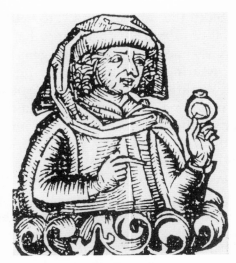

Fig. 12: Prometheus,
Illustration in: Schedelsche Weltchronik, 1493

Fig. 13: Bust of Willibald Imhoff, the elder,
Clay sculpture by Gregor van der Schardt, 1570,
Berlin, Skulpturengalerie der Staatlichen Museen

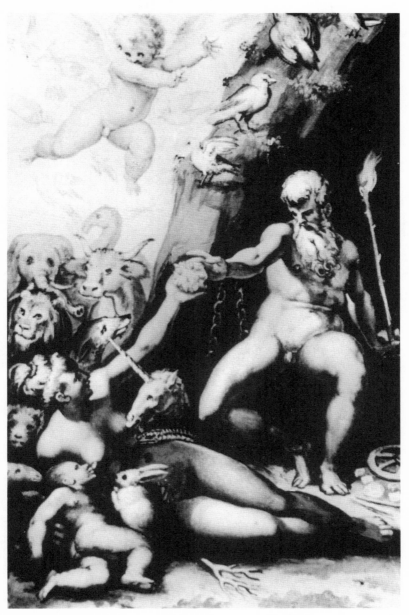

*Fig. 14: Natura and Prometheus, Ceiling fresco by Francesco Morandini,
1572, Florence, Palazzo Vecchio,
Studiolo of Francesco I de'Medici*

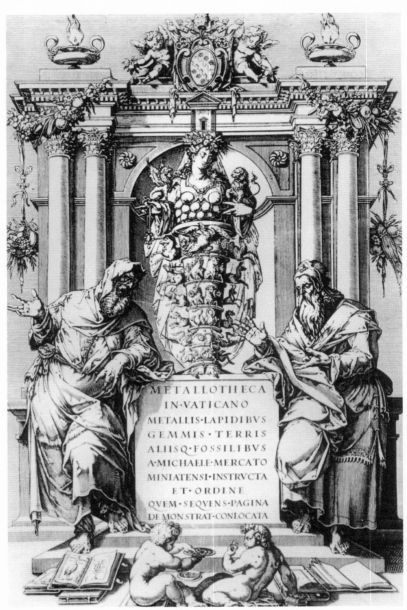

Fig. 15: Allegory of the cabinet of naturalia,
Copper engraving by Anton Eisenhoit, ca. 1580,
Frontispiece in: Michele Mercati, Metallotheca, 1717

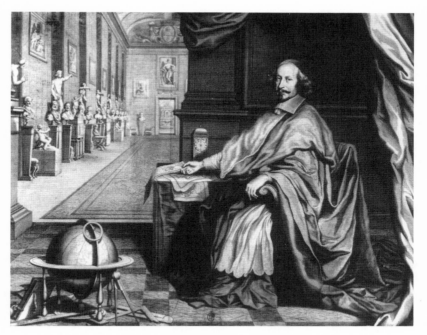

Fig. 16: Portrait of Jules Mazarin,
Copper engraving by François Chauveau and Robert Nanteuil, 1659,
Paris, National Library

Surrounded by books on nature study, two putti lying at the scholars' feet are preoccupied with several rings, once again displaying the Promethean leitmotif of a collection.

By linking the urge to collect with the fire of Prometheus, founder of technology, the dynamic and creative nature of collecting could be accentuated. It could also be used as a political metaphor, which is exactly the focus expressed in François Chauveau and Robert Nanteuil's 1659 portrait of Cardinal Jules Mazarin (fig. 16).[29] It has a sense of depth similar to that of the portrait of the Earl of Arundel (fig. 10). The gallery encompasses an intermediate realm between the foreground and the origin of the room's lines of perspective. It is filled predominantly with ancient statues surrounded by modern paintings, beneath which the most prominent objects are the globe in the lower left and the clock resting on the table.

25

Fig. 17: Metaphysics,
Illustration in: Jean Baudoin, Iconologia, 1644

The meaning of these objects becomes clear from their context. In Jean Baudoin's 1644 version of Cesare Ripa's *"Iconologia,"* the *"Metaphysiqve"* in her role as queen of the sciences is situated between a globe and a clock (fig. 17).[30] However, in contrast to Baudoin's drawing, the tools of geometry, such as a compass, a square, a ruler, and books—that is, the basic instruments of mechanics—are scattered around Mazarin's celestial globe to illustrate how the divine movements of the universe can be put to use on earth. The addition of these objects signals a profound change in the way physics and mechanics had been understood and regarded. In earlier times, physics represented the knowledge of heavenly and terrestrial movements deriving purely from contemplation, and mechanics was a branch of the craftsman's trade. Now the two had merged as theoretical speculation began to avail itself of mechanical aids to foray into nature. Surrounded by technical instruments and appearing to be a kind of living counterpart to the Cardinal, the globe seems to be a monument-like personification of this new conception of mechanics.

Even the clock makes reference to the Cardinal, who is par-

tially concealing a map of France hanging behind him. After a visit to Paris in 1656, Christiaan Huygens invented a precision pendulum clockwork that represented a major improvement over other astronomical methods for locating points on the surface of the earth and made it possible for the first time to produce an accurate map of the provinces of France.[31] Given its qualities as a precision, regulatory instrument, the clock gave added force to the imperial pose of the honorable cleric. The notion of having the fate of the world determined centrally according to the regularity of a clock ticking off seconds was, as Diego de Saavedra put it so well in his handbook for royalty, the best proof of smoothly running absolutism: "Hence a prince should not merely be like the hands of a clock within the machinery of government / but rather the balance spring / that gives the other gears time to turn / since therein lies the art of rule."[32] Within the context of cosmic and terrestrial mechanics, the clock emerges in the portrait of Mazarin as the most important symbol, showing the Cardinal to be the mainspring of his realm, surrounded by the ancient sculpture and works of art, scientific instruments, and mechanical symbols that aided him to this end.

This forms a framework. If we build a chain from Parmigianino's natural work of art via the rings of Prometheus and the other symbols shown in the illustrations of collections and collectors, all the way to the drafting tools and the clock in the Mazarin portrait, the theory of collecting as man's attempt to control nature is extended by introducing the "mechanical" factor. Like a vertical section cut along the time axis, the transformation in the concept of "nature as artist" through antiquity and post-antiquity art is expanded into a chain through the addition of another link, i.e., the products of technology:

> **Natural formations – Ancient sculptures – Works of Art – Machines**

Hierarchy of materials
↳ within distinction

Quiccheberg's Theory

This chain of four links may be regarded as an ideal framework for the type of collection which was exemplified on a miniature scale by the *studiolo* of Francesco I de'Medici and which served as a model for all specialized collections, namely, the *Kunstkammern*, with an encyclopedic inventory, that flourished between 1540 and 1740. There was not a mineral collection, a picture gallery or a collection of antiquities for which the *Kunstkammer* did not serve as a stimulus and a challenge.[33] Given the infinite variety of materials that can be collected, no form of organization can encompass everything; however, the portrayals of collectors and collections that have been discussed here provide a solid foundation, since their inherent limitations have forced the focus to remain on the essentials.

Samuel Quiccheberg's "*Inscriptiones vel tituli theatri amplissimi*," published in 1565, was considered instrumental in setting the parameters for this type of collection. Though intended as an abstract model, Quiccheberg's ideas were also influenced by the *Kunstkammer* of Duke Albrecht V of Bavaria, built between 1563 and 1567. Quiccheberg was also familiar with Camillo's "Theater of Memory," the great collections in and outside Bavaria, and most of all, those in Italy. Though a number of his arguments are not systematically developed, possibly due to local circumstances surrounding the building of the Munich *Kunstkammer*, there are still a number of areas of agreement between his incunabulum on museum theory and previously discussed arguments.[34]

The first section, dealing with the ruler and his realm, begins with the story of God's plan for human salvation. This is followed by genealogies and portraits of the royal families of collectors; maps and views of the ruler's cities and territories and the whole world; models and pictures of wars and campaigns; depictions of celebrations at court and triumphal processions; illustrations of the animals in his territories and of exotic species; and finally, models of buildings, conveyances, and other machines.

The second section is devoted to arts and crafts. It begins with ancient and modern artwork made of wood, clay, marble, and bronze. These are followed by the handiwork of metalsmiths and clockmakers; objects made of wood, stone, precious gems, glass, and textiles; precision instruments constructed by foreign and native craftsmen; vessels recovered from ancient ruins and foreign lands; every conceivable type of surveyor's instrument; ancient Roman coins, foreign coins, and valuable coins of the realm; medallions of famous male and female rulers, scholars, and artists, with symbols on the reverse; small vessels and ornaments fashioned by goldsmiths; and finally copperplates.

The third section contains a systematic presentation of the three kingdoms of nature—animal, vegetable, and mineral. First there are stuffed animal specimens; then lifelike reproductions; important parts of particular animals, skeletons and prostheses; native and exotic roots and seeds; systematic arrangements and illustrations of plants, metals and metallic substances and illustrations thereof, gems and other valuable stones such as marble; paints and dyes; and finally, waters and other liquids of importance in chemistry.

The fourth section is essentially a combined museum of technology and anthropology. Musical instruments are followed by astronomical instruments; measuring devices and clocks; tools for writing and painting; machines for lifting, breaking, crushing, and locomotion, as well as for attempts to fly; tools for sculptors, surgeons, and hunters; playthings to train both mind and body; exotic weapons; exotic, elegant clothing; dolls wearing the traditional costume of foreign nations; and finally valuable pieces of clothing and jewelry belonging to the forebears of the ruling family.

The concluding section is devoted to the uses of panel painting. Outstanding oil paintings are followed by watercolors and copper engravings; family trees; portraits of famous men; coats of arms of noble families; exquisite tapestries and blankets; and finally panels inscribed with maxims and pithy

sayings. These sections are followed by a library, a print shop, a wood turner's workshop, a foundry, and a mint, as well as small exhibit rooms with utensils used by all professions; in short, a comprehensive laboratory.

Quiccheberg's work is unbalanced in its treatment of various subjects. The entire first section and most of the fifth are devoted to the adulation of the ruler and a comprehensive description of his territories and noble surroundings, including the genealogies of a number of famous individuals. On the other hand, sections two through four contain a systematic presentation of natural history and the history of art. The third section, on the three kingdoms of nature, carries the central focus, whereby more weight is placed on classification than on the processing of the objects. The second, comprising mostly sculpture, begins with ancient sculpture which are then juxtaposed with modern works of art.[35] In the case of other objects, e.g. coins and vessels, each survey also begins with examples from antiquity, then moving on chronologically to the present-day within the presentation of each object type. The entire field of modern mechanics—insofar as it was not treated in section one, which deals with territorial descriptions—has been included in the fourth section, which combines measuring devices, mechanical instruments, and clocks with artists' tools. The arrangement does not conform to the rigorous logic of the images of the collection. However, except for exotic items, which will be discussed later in detail, the three middle sections cover all the stages in the sequential presentation—from natural objects through ancient sculptures and modern forms of art, and finally to technical instruments and machines.

The Habsburg Practice

The most lavish collections of their time, in Ambras near Innsbruck and Prague, present a similar picture. Starting in 1573, Archduke Ferdinand of the Tyrol commissioned the con-

struction of a complex of buildings that, for the first time in the history of post-antiquity architecture, was designed specifically for the purpose of housing a collection (fig. 18).[36] The *"kunstcamer"* installed in the third building contained a vast number of various objects stored in twenty separate display cases.[37] The process of transforming natural objects into works of art using the tools of art and technology was depicted with respect to each of the individual natural materials included in the collection. The first few cases reflect the hierarchy of materials, ranging from gold to silver to precious handstones. Wenzel Jamnitzer's deceptively lifelike reproductions of plants and animals offer particularly outstanding examples (fig. 24).[38] The "regal materials" are followed by musical instruments, tools, timepieces, and automatons that represent the means of applying mathematics and mechanics in practical terms. After this presentation of tools and instruments, linking theory and practice, the hierarchical display of materials is resumed, with stone statues and works wrought of iron. The next case is filled with books, representing another connecting link, dedicated not to the fabrication process *per se*, but the knowledge involved. The rest of the cases deal with natural materials and their development into products, as follows: ornamental feathers, ivory, alabaster, glass, coral, cast metal, porcelain, and wood.

The *Kunstkammer* collections were organized roughly according to the hierarchy of the materials. Each material was examined in light of the various historical periods and shown at every stage of its development—from its unadorned natural state to the specious naturalism of the "rystique" style meshing nature and art, to its elevation to a "pure" work of art. The hierarchical system of attributing a value to natural materials came under the enobling aegis of the Promethean practice of designing the materials.

Similar developments took place in the Prague *Kunstkammer* of Emperor Rudolf II. Long considered the product of a deranged mind,[39] after the publication of an inventory

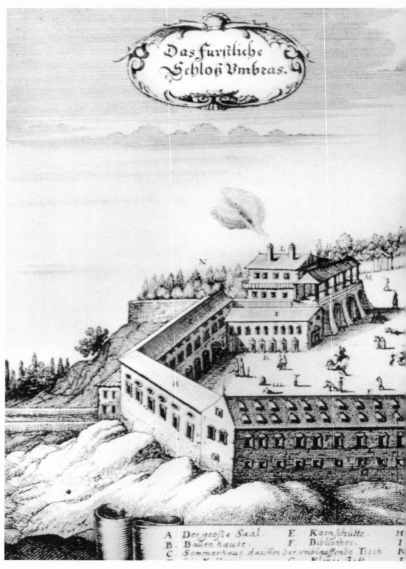

Fig. 18: *Schloss Ambras, Copper engraving by Matthäus Merian,*

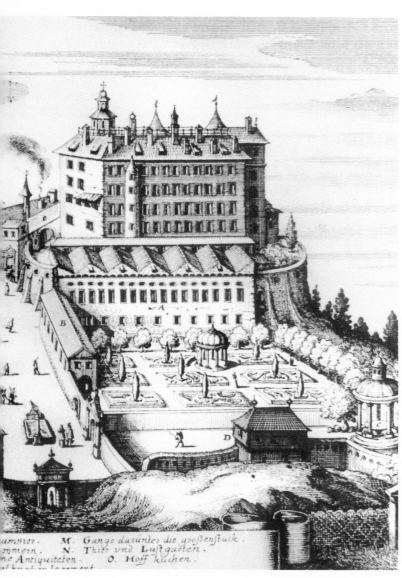

in: Topographia provinciarum Austriacarum, Frankfurt/M. 1649

(1607-1611), the emperor's *Kunstkammer* was restored its repu-
tation as a museum with a clear, in some sense pre-Cartesian
form of organization.[40] The inventory, presumably the work of
the painter Daniel Fröschl, is of such great significance because
it is a classified list of the objects irrespective of location, rep-
resenting both a catalogue and, at the same time, a classifica-
tion scheme.[41] The historical treatment of the various areas of
the collection is more transparent than even Quiccheberg's
approach to museology, as the objects of the kingdom of
nature, the *naturalia*, are introduced at the beginning of the
work and not in the middle. Ancient sculpture has also been
included in this category, since paleontological artifacts, fossils,
and archaeological findings, as well as minerals and products
derived from them, are found here.

Objects from the mineral kingdom are followed by speci-
mens from the vegetable and animal kingdoms. The next cate-
gory, *artificialia*, is dedicated to arts and crafts. Here, refined
objects made from organic and inorganic materials, such as the
inlay work of Giovanni Castrucci,[42] give the impression of dis-
solving the boundary between natural and human creations.
They are followed by works from all the other branches of the
arts, to the extent that their size permitted inclusion in the
Kunstkammer collections. The last category, *scientifica*, includes
globes and instruments used to measure time and space. This
category also covers the measuring devices, clocks, and
automatons found in Tycho Brahe's observatory and mathe-
matics tower. Collections of other items such as decorative
weapons, tapestries, and various other pieces of equipment,
and paintings and ancient sculptures whose origins could no
longer be precisely identified, were rejected simply for lack of
space. While viewing the contents—the largest assembled to
date by a single individual—Alessandro d'Este expressed his
admiration for the collection as a whole: "Paintings..., costly
vessels of every variety, statues and timepieces; in sum, a trea-
sure worthy of its owner."[43]

Though *exotica* was an important area of collecting that was

woven into all three kingdoms of nature as well as the sphere of *artificialia*, it was not specifically accommodated in this classification system. The universality of the vegetable kingdom was reflected in the collection of fruits and nuts from America and Asia, and there also were a number of samples of *exotica* among the stuffed animals. *Exotica* was of no less importance in the area of *artificialia*, where it was introduced through the arts and crafts of the peoples of East Asia and the Americas.

The Ambras collection had followed a similar strategy. It possessed the oldest collection of non-European *exotica*, subsuming everything under the general heading of "Indian."[44] The worldwide territorial claims of the Habsburgs—as clearly and inimitably depicted on Wenzel Jamnitzer's *"Weltschale,"* a bowl originally housed in the Prague *Kunstkammer*[45]—doubtless contributed to the urge to document foreign cultures.

Nevertheless, interest in *exotica* signified more than simply the wish to subjugate other peoples. In fact, even Quiccheberg's theory of museums had advanced from the extensive documentation of one's own country to the collection of foreign art and costume. Quiccheberg placed exotic objects in sections two and four of his *"Inscriptiones,"* i.e., those sections dealing with objects showing human workmanship on natural materials. It seems particularly strange that Quiccheberg included exotic weapons and costumes in section four, as they appear rather unexpectedly after the utensils and playthings. He may have been influenced by the idea that the Age of Discovery had begun at the same time as modern utensils and measuring devices were being developed and that evidence of foreign peoples was somehow a product of the *artificialia* collected in section four. However, since exotic materials were placed side by side with native European objects, they in fact constitute the first evidence of a kind of ethnology that viewed foreigners with a certain respect. Objects from overseas have been integrated visually in a non-hierarchical fashion. In fact, exotic costumes take on such weight that in contravention of the classification scheme they are listed as the final subcate-

gory in section four, inviting comparison with the oppulent costumes of the ruler and his forebears.

Territorial surveys of the various countries and the isolation of the exotic attest to the desire to understand the earth in its horizontal, spacial entirety. Thus the *Kunstkammer* combined the three vertical stages of development—from *naturalia* to *artificialia* to *scientifica*—with a horizontal plane that represented efforts to research the entire globe. In a certain sense, then, the *Kunstkammer* were at one and the same time like time-lapse photography *and* microcosms of the world.

RESEARCH AND VISION

From Kepler to Locke

The visual impact of the objects displayed in the *Kunstkammer* had a profound effect on the thinking of natural scientists. This can be seen, for example, in the enthusiasm expressed in 1598 by Johannes Kepler upon seeing a display of clocks and automatons with figures from classical mythology, buglers, and a "drummer, who," as Kepler noted, "beat his drum with greater self-assurance than a live one."[46] These machines inspired him not only to produce a diagram of the cosmos (fig. 19),[47] showing it as consisting of five geometric solids driven by a clockwork mechanism,[48] but to commission a goldsmith to create a three-dimensional model of it for Duke Friedrich of Württemberg.[49] In contrast to clocks made by "other artisans," in which only the tactile dial provided something for the senses, Kepler's hemisphere with its open top displayed its superiority by directing "the eyes" to the very heart of the cosmic machine.[50]

Kepler thus radicalized the mechanistic traditions of the 16th century that referred back to the Old Testament praise of God that "You ordered all things by measure, number, weight."[51] Scripture in hand, Renaissance philosophers of art and mechanics justified their view of nature according to Plato's notion that the cosmos was a mathematical construct based on numbers and proportions, leading inevitably to a synthesis of mathematics, art, and mechanics.[52]

At the end of the 16th century, at the same time Kepler was formulating his theories, the mathematician Henri de Monantheuil attempted to convince Henri IV of France that God was a *"mechanikos"* and omnipotent among mechanics. De Monantheuil maintained that the universe was "a machine and doubtless the most powerful, practical, and elegant con-

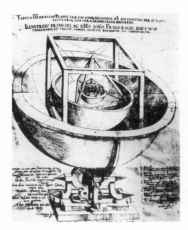

Fig. 19: Model of the cosmos
"Machina mundi artificialis,"
Copper engraving in: Johannes
Kepler, Mysterium
Cosmographicum, 1596

Fig. 20: Mathematical
chance images,
Illustration in:
Ulisse Aldrovandi,
Musaeum Metallicum, 1648

Fig. 21: Turned figures by Nicolas Grollier de Servière,
Copper engraving by Etienne-Joseph Daudet,
in: Gaspard Grollier de Servière,
Recueil d'ouvrages curieux, 1719

38

trivance of all time." As though intending to provide a commentary on Kepler's model of the universe, de Monantheuil concluded by saying that since man had been created in the image of God, he had the duty to emulate the divine mechanic and create objects that could compete with those of nature.[53]

This carried overtones of the historical approach that comprised the conceptual foundation of the *Kunstkammer*, that is, the series of steps leading from natural objects to machines. This gentle transition from natural forms to human creations promoted the most powerful school of thought of the 17th century, namely, mechanistic philosophy.

In 1647, René Descartes, foremost representative of this school, maintained that except for their size, he could see "no difference between machines built by artisans and objects created by nature alone."[54] His words indicate that, like other philosophers of nature, he too had been impressed by the *Kunstkammer*, which for three generations had been using its mute images to depict the transition from natural formations to art forms.

Aldrovandi's *"Musaeum Metallicum"* is an example of a visual realization of this metamorphosis from natural formation to a work of art. It included not only *"Icones"* (fig. 4), but geometric solids as well, that were created by nature itself, thereby revealing the structural principles inherent in nature (fig. 20).[55] The human-made counterparts of these natural structures were *"pièces excentriques,"* displayed in unsurpassed diversity in the collection of machines assembled by Nicolas Grollier de Servière around the year 1650 (fig. 21). These wood turner's creations, the "beauty" of which derives from the "complexity" of their construction, represent a playful introduction to the presentation of machines.[56] Such products of the wood turner's workshop were some of the most popular items in the *Kunstkammer*, since they had been passed down as works of royalty, starting in the early 16th century. The ruling houses of Europe, particularly the Habsburgs, used magnificent wood-turning lathes to emulate the demiurge, the "first wood

turner," who had created the world with such artistry.[57]

In 1674, Kiel physician Johann Daniel Major definitively established the connection between Cartesianism and the philosophy of the *Kunstkammer*. Later, he even placed a portrait of "Descartes, that fine Copernican who has rarely been refuted by anyone," in a position of prominence in his private collection.[58] In the introduction to his treatise reflecting on cabinets of art and natural curiosities *"Bedencken von Kunst- und Naturalien-Kammern"* (1674), the first work on the philosophy of museums since Quiccheberg's *"Theatrum,"* Major praised man as the finest of nature's clockworks, displaying "well-proportioned limbs / marvelous pathways for blood and water / and all the movements of the extremely artistic clockwork mechanism of the entire human body / aside from which there is no more noble and beautiful creation on the face of the earth."[59] Despite this perfection of form, according to Major, humanity continues to face the challenge posed by Adam's expulsion from the Garden of Eden, as a result of which he lost "his understanding or desire for truth and knowledge about all the things of beauty in nature." The Fall had caused Adam "to erase from his mind / wilfully / even fiercely and foolishly / the many magnificent and beautiful things recorded therein; however / at least / now that the slate is clean / so far as still possible for us / something can be written upon it anew."[60]

Major's scholarly appeal to Descartes to return to Paradise was a restatement of the fruitful, historical motivations that underlay the desire to collect. According to Major, innate human curiosity represented a bridge in time leading back to, or beyond, the blissful state of knowledge that had existed prior to the Fall of humanity's primeval ancestors. Since the 16th century, books on mechanics had nurtured the belief that with the help of technology, humankind could "from the depths of darkness. . . be lifted / and. . . approach its primeval state of perfection."[61] Reattainment of Paradise conformed to this way of thinking, taking place as a series of entries onto the *tabula rasa* that was Adam's mind. The *Kunstkammer* became a meta-

[handwritten margin note: Crapo departments !]

[handwritten note at bottom: Garden of Eden = Ignorance, not knowledge.]

phor for the human brain gradually reacquiring Edenic wisdom.

John Locke's famous "white Paper, void of all Characters," onto which ideas are entered to expand the consciousness, stands in the same tradition as Major's concept of an Adamic tablet.[62] It is less well-known that Locke also compared the filling of a collection room to the creation of the human intellect from its original void state. An initial act fills this "yet empty Cabinet" with senses, insofar allowing individual ideas to enter; in further steps, these elements receive names and characterizations, in order to structure the memory in such a way as to facilitate discourse.[63] In keeping with the *Kunstkammer* model, Locke considered this cabinet to be a container for all things of the physical world which could be represented in pictures. In contrast to the unwritten "white Paper," the empty cabinet is a "dark Room. For, methinks, the Understanding is not much unlike a Closet wholly shut from light, with only some little openings left, to let in external visible Resemblances, or Ideas of things without; would the Pictures coming into such a dark Room but stay there, and lie so orderly as to be found upon occasion, it would very much resemble the Understanding of a Man, in reference to all Objects of sight, and the Ideas of them."[64] Thus Locke linked the imprinting of characters on the *tabula rasa* to the filling of a collection, in an attempt to explain the structure of the human mind.

Three years after the publication of Major's *"Bedencken,"* an inventory of Ferdinando Cospi's *"museo"* was published as well. The *"museo"* occupied a place of particular importance in Italy because it incorporated Aldrovandi's private collection (fig. 22).[65] On the frontispiece, objects from each of nature's three kingdoms, ancient sculpture, works of art, tools, and weapons are depicted, similar to the catalogue of Rudolf II's collection, in an attempt to bring systematic clarity to such a vast number of objects. Cospi stressed the similarities between his collection and mechanistic thought succinctly: "Those brilliant creations *(machinamenta)* of art and Nature exalting

41

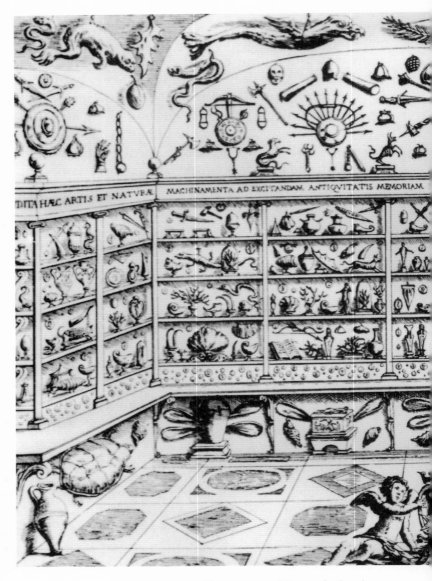

Fig. 22: The museum of Fernando Cospiano,

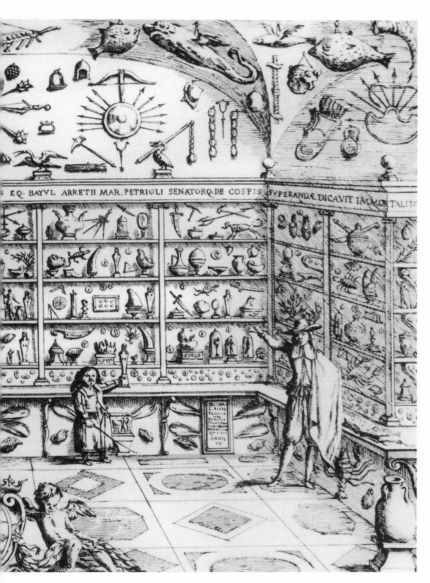

Frontispiece in: Lorenzo Legati, Museo Cospiano, 1677

(excitandam) the memory of antiquity." Both conceptually and in terms of organization, the *"museo"* was thus divided into the four categories: nature, antiquity, post-antiquity art, and machinery. Once again, the *Kunstkammer* was ranked first in the hierarchy of museum collections. As repositories of *"machinamenta artis et naturae,"* they reflected a desire to analyze and comprehend all the objects and forces that make up the world, without losing sight of antiquity in the process. Humanity was thus placing its valuable *artificialia* on a par with the artful creations of nature. It is especially significant that the term *"machinamenta"*—a word not easily translated—captured the broader meaning of the *Kunstkammer.* Analogous to the Italian *"machina,"* and in keeping with Cartesianisim, it encompasses all objects collected with a particular purpose in mind—natural formations as well as sculpture, buildings, paintings, instruments, and machines.[66]

It an attempt to represent Cartesian thought visually, the engraver Clément Pierre Marillier finally chose an idealized form of the *Kunstkammer* which he depicted in 1762 as an arcade (fig. 23).[67] Around the massive base of an overgrown arch that symbolized antiquity, Marillier gathered various fossils; terrestrial and aquatic animals; technical instruments from the fields of physics, chemistry, and mechanics; and books. The figure of the infant *Melancolia*[68] is sitting on top of a skull in the pose of a brooding thinker. The loose arrangement of objects on the stone base creates the impression of a deliberate design that at the same time is supposed to look natural. Because of the resulting tension, which was first encountered in Parmigianino's painting, a programmatic detail was inserted: Partly concealed by a medallion with the portrait of Descartes, a landscape relief is hanging among the fossils on the edge of the base, and it is impossible to tell whether it was a product of human workmanship or whether nature created it "by chance."

Damaged by the forces of nature yet still solid, the arch likewise serves a dual function. As in Mercati's drawing, the

Fig. 23: Philosophy, copper engraving by J. Arrivet,
Design by Clément Pierre Marillier, 1762,
Paris, National Library

sturdy ruin represents the interface between the creations of
man and those of nature. It is meant not as an example of the
vanity of all creative achievements,[69] but as an affirmation of
the truth of Cartesian philosophy, which symbolically radiates
rays of sunlight that bypass the infant *Melancolia* and ultimate-
ly illuminate a round mirror. The arch holds in its keystone the
key to eliminating the conceptual boundaries between the cre-
ations of nature and of man, thereby transforming the ancient
ruin into the triumphal arch of Cartesianism. Not only the tools
and devices for studying nature themselves, but also their
interplay with ancient architecture represent a symbolic
endorsement of the mechanistic model of the universe as
exemplified in the philosophy of the *Kunstkammer*.[70]

Movement and Magic

The inherent meaning of the *Kunstkammer* was by no means limited by their mechanistic structure; on the contrary, it was expanded therein. One of the most surprising elements of mechanistic philosophy is that it also supported the expression of occult tendencies that were long considered the sheer opposite to "cold" Cartesian thought.[71] The strongest connection between these two apparently incompatible schools of thought could be found in attempts to synthesize life. Since life in its highest form was defined since Plato's time as the ability to move independently, the creation of movement became the decisive criterion.[72]

The process began by creating an illusion of life and nature, a technique that derived from classical aesthetics.[73] Despite the existence of various opposing theories of art, the idea of imitating life continued to be a major criterion in aesthetic judgment. Prince Karl Eusebius of Liechtenstein (1611-1684), one of the most important collectors of his time, for example, evaluated a work of art according to whether the images reproduced seemed "natural" and "lifelike," and whether the "position and movements" of the figures were credible. Human beings as well as animals were to be represented in painting "as if they were alive, running about, or whatever they should be doing."[74]

These remarks by Prince Karl pertained chiefly to paintings. The painter was obliged to evoke life solely through form and color, forcing viewers to complete the illusion of life in their own minds. Using sculpture, it was easier to create an illusion of life, as a result of the technique developed in the 15th century for preparing casts of natural objects. Wenzel Jamnitzer's reproductions of plants and animals created a fantasy world of living creatures "as they have grown in nature."[75] Quiccheberg's handbook on the *Kunstkammer* devotes an entire chapter to these reproductions: "Animal sculptures cast in metal, plaster, clay, and all manner of artistic materials. All the

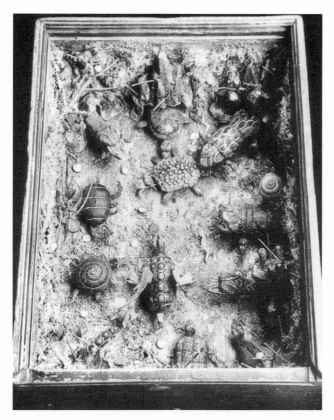

*Fig. 24: "Schüttelkasten," 2nd half of the 16th century, Vienna
Kunsthistorisches Museum, Schloss Ambras collections*

reproductions look alive, including the lizards, snakes, fish, frogs, crabs, insects, clams and the like. The effect is usually improved through coloring to make them appear real."[76]

The figures were enhanced by means of internal and external movements. Small boxes to be shaken, so-called *Schüttelkasten*, were a small-scale example of this. The *Schüttelkasten* from Ambras (fig. 24) displays a remarkably realistic forest floor made of moss, shells, plaster, wood, paper, and wire. A collection of turtles, snails, lizards and other reptiles is loosely fastened onto this floor. When the box is shaken ever so

slightly, the creatures inside appear to move, as though twitching and squirming.[77]

Like on the stage of a theater, the *Kunstkammer* demonstrated all the various stations in the transition from an inert natural material to an animated body. Since the sense of an upward spiraling spacial rotation depicted in mannerist figures was meant to convey an internal movement to the surroundings and the viewer[78] through the principle of *"figura serpentinata,"* it is not surprising that in the Prague *Kunstkammer* of Rudolf II, Giambologna's "Rape of the Sabine Woman" and two minor copies of the Laocoön were placed next to a set of antlers, an artistic work of nature seeming to reach out as if alive; nor that a figure of Mercury was placed close to an automaton. The counterpart of the *Schüttelkasten* were landscapes filled with automatons in which entire groups of mechanical figures were shown harvesting crops or carrying out other activities.[79]

Such automatons were the most obvious expression of the desire to imitate life by inspiring movement. The fourth link in the chain of historical periods—**natural formations – ancient sculptures – works of art – machines**—could thus be derived from these self-propelled works of art, in the form of the legendary automatons of Daedalus in Greek mythology. Their fame owed to their apparent creation on the basis of insight into the laws of mathematics and their applications.[80] In medieval automaton legends,[81] the Daedalus reports were filtered by the *"Occulta philosophia,"* by Heinrich Cornelius Agrippa von Nettesheim (1486-1535), in which the preference for natural sciences was combined with magical interpretations, yielding a peculiar mixture of occultism and enlightenment. According to Agrippa, ancient science had proven that amazing things could be achieved when knowledge of natural philosophy and mathematics was applied to practical subjects: "those [creations] of Daedalus, called *'simulacra'* and *'automata'* by the ancients, were of the sort which Aristotle remembered; Vulcan's and Daedalus's self-propelled three-legged creations, of which Homer told that they went into battle of free will, and

about which we read in the works of the gymnosophist Hiarbas that they moved of their own doing to the banquet, and of the golden statues that carried out the tasks of the cup-bearers and the servers at the banquet."[82] Reminiscent of Agrippa, the "mathematical magic" of mathematician John Wilkins (1648) celebrated Daedalus "to be one of the first and most famous amongst the ancients, for his skill in making automata, or self-moving engines."[83]

Automatons also found a place in aesthetics. Giovanni Paolo Lomazzo's treatise on painting (1584) focussed on the transition from imagined movement to mechanical and lifelike movement as a stable condition of artistic and art-technological practice. In the chapter on the physics of movement, he made a smooth transition to a presentation of the history of automatons up to the most recent developments,[84] in the same manner as they were documented at that time in the *Kunstkammer*. In Prague, in addition to the automatons mentioned, there were also some built into timepieces or combined into independent groups, including pipers, drummers, a dog, and a turtle that could move.[85]

These constructions found a special place in grottos and gardens, where they satisfied expectations on a larger scale. Here was a perfect location in which to manifest the transition of apparently untouched yet structured nature to art in the style of antiquity and finally to automatons brought to life, since the grottos were viewed as anthropomorphic "wombs" where metals became more highly developed, as though in an underground laboratory.[86] The most important grotto artist was the talented Bernard Palissy, one of the first empiricists to acquire a firm standing in the history of science. Palissy was not an opponent, but a heretical follower of alchemy. One of his landscape designs included gardens, arbors, and grottos as well as a *"gallerie"* carved into the rock, with various figures enamelled *"si près de la nature"* that they were spontaneously greeted by visitors. Behind it, various rooms with a library, seed storerooms, and laboratories extended deeper into the

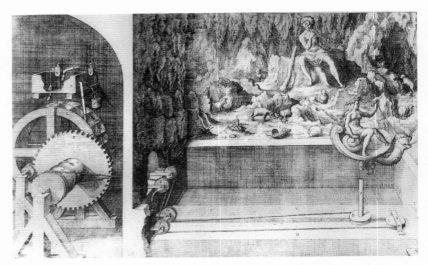

*Fig. 25: Polyphemus and Galatea, grotto automatons by Salomon de Caus,
Illustration in: Salomon de Caus,
Von gewaltsamen Bewegungen, 1615*

rock.[87] In nature's innermost sphere, interest in nature was embodied in the triad of traditional knowledge, experiment, and practical use of natural materials; at the same time it created a larger scale external example of that which the *Kunstkammer* represented in the inner area of the palace architecture.

The work of artist, engineer, and scholar Salomon de Caus also conveys an impression of the complexity of such grottos. De Caus was familiar with the fountains and automatons at the *Villa Medici* in Pratolino and the *Villa d'Este* in Tivoli. His work was modelled on the ancient *"Pneumatica"* by Heron.[88] One of his most sophisticated inventions shows a grotto with Polyphemus sitting amidst the rugged rocky landscape surrounded by sheep and rams, snails and shells, playing a shawm, while Galatea and two dolphins are perpetually moving back and forth in the pool in the foreground (fig. 25).[89] In the room adjacent to the grotto stage, the imposing machinery running the mythological scene is depicted with equal signifi-

cance to that of the scene itself. The water alternately turns either the wheel rotating left or the one rotating right, so that when this rhythm is transferred to Galatea's shell, it causes the shell to change direction when it reaches the end of the track.

Laboratory

Secret goal –

No occult tendencies could be verified in de Caus's works.[90] However, the Rosicrucian manifestos written from 1614-1616 by Johann Valentin Andreae, as well as the no less significant *"Theatrum Sapientiae"* by Hamburg Rosicrucian Heinrich Khunrath,[91] speak of mysterious grottos which hold the secret to a worldwide reformation triggered by mathematics, physics, and magic; also, this hope was centered around the Heidelberg court. For these reasons, it seems likely that de Caus's grotto automatons represent the secret goal they referred to.[92] The *Kunstkammer* was an above-ground equivalent to the underground laboratory caves, thus representing the corresponding final goal with respect to a collection.[48] In his *Chymische Hochzeit* [Chemical Wedding], Andreae described an insular laboratory palace with some characteristics of a huge *Kunstkammer*. In one of the rooms, "pictures, paintings, timepieces, organs, small spouting fountains and the like are not lacking,"[94] and the rooms explicitly referred to as *"Kunstkammern"* were described as follows: "There we saw such wonderful creations of nature and other things which human reason had created to imitate nature, that we shall have had enough to look at for a year."[95] The perhaps most well-known 17th century English *Kunstkammer*, the museum of Rosicrucian Elias Ashmole, can be regarded as an attempt at rendering this vision.[96]

Palissy's and Andreae's ideas of using the *Kunstkammer* as an active laboratory rather than just a passive collection corresponded to the Promethean practice of perceiving the actions of collecting, researching, and structuring as a unit.[97] Even

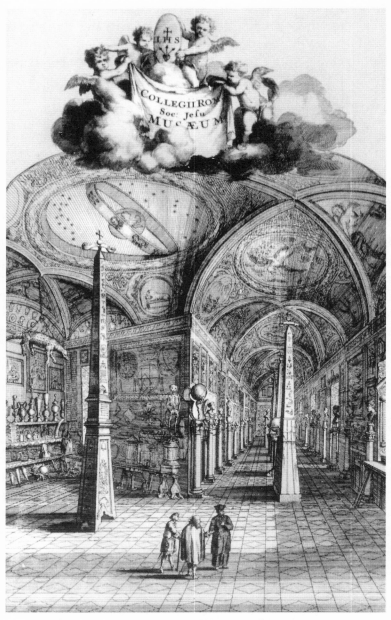

Fig. 26: *Museum of Athanasius Kircher,*
Frontispiece in: Giorgio de Sepi,
Romani Collegii Societatis Jesu Musaeum Celeberrimum, 1678

52

Fig. 27: Title vignette of the founding documents
of the "Istituto delle Scienze," Bologna, 1728

Quiccheberg's *"Inscriptiones"* let the division of the different *Kunstkammern* flow into the description of the respective work-shops.[98] For emperors and nobility, active participation in research and the processing of materials, such as that leading to the development of the valuable wood-turning lathe, meant clear evidence of their absolute rule, emphasizing not only their representative dignity, but also—and in particular—their active control of the outside world.[99] The *Kunstkammer,* once it was stripped of rulers' claims, became an impetus for universities and academies as well as all institutions attempting to link theoretical reflection with practical work.

The *Tribuna*—which was commissioned by Francesco I and, after his death in 1587, continued by his successor, Ferdinando I de'Medici—including the adjacent corridors in the Uffizi of Florence, represented a decisive new stage. After the work was completed in 1589, the gallery had grown to be an unprecedented collection of *Kunstkammern* and workshops. It was by no means contradictory for the productive character of the ensemble that the *Tribuna*, the showpiece of the work, had been influenced by antiquity. The organization, as developed through sculptures and painting of the gods and the deeds of Hercules, was in keeping with a late-antiquity model of the cosmos; its octagonal form and the weather vane pushing

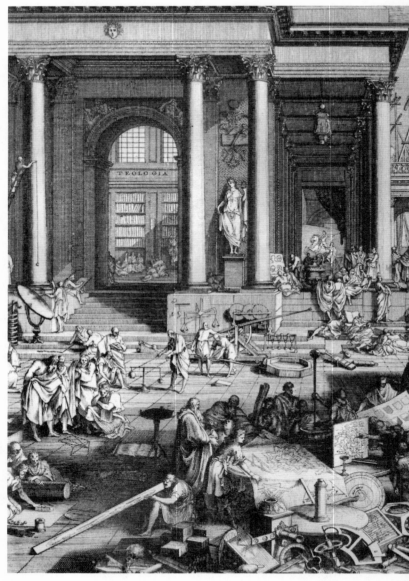

Fig. 28: Academy of the Sciences and the Fine Arts,

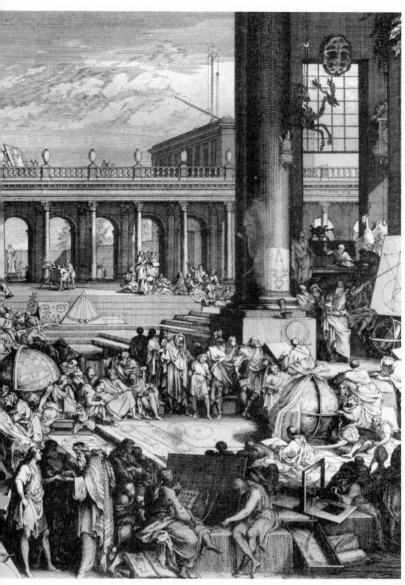

Copper engraving by Sébastien Leclerc, 1698, Paris, National Library

through the dome were taken from Vitruvius's description of the wind tower of Athens. Even the zodiac in the dome could be traced back to Vitruvius.[100] A *Kunstkammer* cabinet in the middle of the *Tribuna* repeated the form on a small scale, its sections reproducing the different collection areas in miniature. This small *Kunstkammer* was topped with eight busts of the Roman emperor crammed onto the architrave.[101] The *Tribuna* was surrounded by the weapons collection, a room with bronze figures, and additional rooms with scientific instruments and objects from the three kingdoms of nature. Finally, there were workrooms with "craftsmen of every trade, ability, and rank."[102]

The gallery at Pisa was also founded under Ferdinando I, who had commissioned the completion of the *Tribuna* complex. It was expanded from a collection of natural history specimens to a complete *Kunstkammer*, with works of art as well,[103] and as an integral component of the university it was one of the first examples displaying an internal relationship between a *Kunstkammer* and autonomous research and curriculum. According to this model, German mathematician, ethnologist, historian, and linguist Athanasius Kircher's *Museum Kircherianum* became affiliated with the Roman Jesuit college. It was the most famous and comprehensive Italian *Kunstkammer*, based on a collection of ancient artifacts that had been expanded starting in 1651. The frontispiece of the inventory shows Kircher explaining the exhibition pieces (fig. 26).[104]

The research foundations established by Luigi Ferdinando Conte de Marsigli of Bologna clearly illustrate the stepwise development, starting in 1690, from a *Kunstkammer* to a public research facility. Since Conte converted his house—complete with a library including his comprehensive collection of minerals, plants, animal samples, ancient art and other works of art, scientific instruments, automatons, and a university laboratory—into the "*Istituto delle Scienze*," his *Kunstkammer* played an important role in the birth of institutionalized research. The title vignette of the founding documents (fig. 27) used exem-

plary objects from the fields of mineralogy, zoology, botany, antiquity, art, mechanics, and book learning to depict a *Kunstkammer* collection in a similar manner as Marillier's later visualization of Cartesian philosophy (fig. 23).[105]

Not all academies had a *Kunstkammer*, but ever since its founding in 1662, the London Royal Society, one of the most influential of all institutions of its kind, expressed intentions to create such a collection.[106] The *Académie Royale des Sciences*,[107] founded in 1666 in Paris, had a collection of machine models, thus incorporating only one aspect of the *Kunstkammer* concept. When copper engraver, mathematician, and physicist Sébastien Leclerc drafted an ideal image of the *"Académie des Sciences et des Beaux Arts"* (fig. 28) in 1698, however, he rekindled the entire concept of the *Kunstkammer*.[108] The ancient dress of the researchers and artists stresses the reference to antiquity. The mechanical, mathematical aspects of natural history research occupy the foreground, while the fine arts and music fill out the center and the background. Theology, as a field of study limited to book learning, is forced to the side. The temple of philosophy and contemplative natural history research that Raphael envisioned in "The School of Athens" was thus transformed into a grandiose forum that was taught by the *Kunstkammer*—a forum of fine arts and technology, philosophy and applied science, basic research and practical applications, the lure of antiquity and the cult of the machine.

Utopia

Leclerc's engraving completed an impulse that was likely triggered by the Uffizi *Tribuna*. The *Tribuna* must have made an incomparable impression during its peak, since it offered, through the promise of feverishly active laboratories and workshops, an almost futuristic extension to the historical and successive moment that developed from nature and extended

through antiquity up to the present day. Thus it is no coincidence that the elaborate, technically inspired utopias were written during the time between the Uffizi *Tribuna* and Leclerc's engraving. The *Kunstkammern* might have had an even greater influence on these visions than on the academies, since their magnificent and idealized infinite collections—aimed at the entire world and history—of the greatest possible variety of objects had *per se* utopian character. Tommaso Campanella's "*Civitas Solis,*" written in prison in 1602 and not published until 1613, displayed aspects of an enormous *Kunstkammer.* There are valuable paintings on six of the seven ring-shaped city walls. From the inner wall of the first ring to the outer wall of the sixth, rows of pictures from the fields of mathematics, geography and ethnography, mineralogy, hydrology and meteorology, botany, zoology, and mechanics are aligned, ending with the great inventors and historical personalities. The order of the images in this series resembles that of the catalogue of Ferrante Imperato's Neapolitan *Kunstkammer,* which was published in the same year that Campanella started writing his utopia.[109] Here pictures were used to classify the total knowledge of all natural and synthetic beings and objects, their uses, and their relationships to heavenly bodies and human beings. In addition, the pictures refer to samples of the illustrated objects and the respective workshops;[110] this practice must have been a reaction to the principle developed in the *studiolo* of Francesco I de'Medici, to use works of art to denote the content of the collection cabinets. In any case, the temple rising up in the middle definitely took up elements of the Uffizi *Tribuna* with its domed central construction with a painting in its vault, not only of the stars, but the compass directions as well; and a revolving weather vane showing the direction of the wind also pushes through its lantern.[111]

Four years after Campanella completed his work "*The City of the Sun,*" Kepler's "*Tabulae Rudolfinae*" was published, with a frontispiece by copper engraver Georg Cöler, based on a sketch

made by Kepler himself. Reminiscent of Campanella's helio-centric sun-city temple, Tycho Brahe created a synthesis between a geocentric and a heliocentric cosmos, which was then put on the ceiling (fig. 29).[112] Famous natural scientists fill the inside of the *tempietto*, and Hven Island, in the Danish Sound, can be seen on the front part of the pedestal level. The unique research facility *Uranienborg* was set up there by Brahe, with the support of Frederick II of Denmark; as a small, insular scholar's republic, it seemed to confirm the lure of island utopias.[113]

The Urania Temple is vaguely connected to a poem in which Kepler referred to Urania in a commentary to his main work, *"Nova Astronomia"* (1609):

I examined first the normal orbits of the planets
And the terrible danger that threatened the cracked walls,
Since the columns of the world have already begun
 to totter.
Darkness surrounded the origins. The chorus of scholars
faithfully trusted in the Prutenic masters.
Then I set to work, in the hopes that I could succeed
in supporting the roof of the heavens with a new sill.
Splendid building timber was brought to me with the
 five solid bodies
By the one from Samos; Euclid gave me the guidelines,
 Pallas the insight
And Urania often provided, through her scholars,
Approval and happily announced the celebration of the
 victory.[114]

In its unfinished form, the back temple supports in the engraving could allude to the danger mentioned in the poem, that "the columns of the world have begun to totter." Contrary to this, however, the temple is no less dependent on the strength of their support than on that of the modern columns. These do not appear in place of the ancient supports; rather,

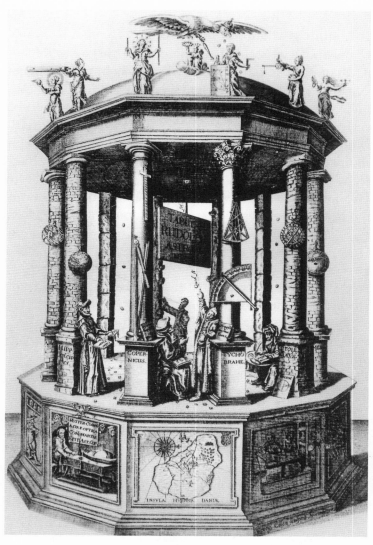

Fig. 29: Temple of the "Tabulae Rudolfinae,"
Copper engraving by Georg Cöler; Design by Johannes Kepler,
Frontispiece in: Johannes Kepler, Tabulae Rudolfinae, 1617

they eliminate the damages from the tremors that shook the post-antiquity world.

The round temple filled with utopian images resembles the *tempietto* of the *"Metallotheca"*[115] (fig. 9); the historical symbolism of this engraving is also repeated, in which history is divided into various spacial stages from the realm of pre-historic, natural history to antiquity, up to modernity. The stacked, crude square stone blocks forming the back columns represent Chaldaic and Babylonian sciences. In the *Metallotheca* they are depicted by the border zone defined by the ruin, in which natural forms and anonymous human intervention are balanced. The brick columns on the sides are attributed to Aratus, Hipparchus, Ptolemy, and Meton, heroes of antiquity, and the two front columns, giving the construction the splendor of marble, are dedicated to Copernicus and Brahe. The stages of history are once again perceived as different ways of processing natural materials, so that a four-linked chain is depicted here as well, from the natural form (the crude back supports) to antiquity (Roman brick columns with models of the cosmos and calculation tables) to the valuable, more recent works of art (the marble columns in the front), and finally, to the most advanced instruments hanging from these columns.

In 1627, when Kepler's *Tabulae Rudolfinae* was published, Francis Bacon's utopian *New Atlantis* also appeared in its Latin translation. The English version was most likely published in 1623, the same year as Campanella's *The City of the Sun*. Bacon's island utopia centers around the *"domus Salomonis,"* which can be seen as a gigantic, imaginary *Kunstkammer*.[116] There are also automatons in this complex, which further "the knowledge of the Causes and secret motions of things and the enlarging of the bounds of Human Empire, to the effecting of all things possible. . . . We have divers curious clocks, and other like motions of return, and perpetual motions. We imitate also motions of living creatures, by images of men, beasts, birds, fishes, and serpents. We have also a great number of other various motions, strange for equality, fineness, and subtilty."[117]

Two halls of columns are the culmination of "Salomon's House." "For our ordinances and rites: we have two very long and fair galleries: in one of these we place patterns and samples of all manner of the more rare and excellent inventions: in the other we place the statua's of all principal inventors."[118]

The temple-like appearance of the two halls of honor shows the continued influence of antiquity, in front of which the most modern technology and inventors are revealed. Antiquity offers both a reflective and a permeable membrane for these hopes for evolution of man and technology; although recent and future inventions break with antiquity, the stage that is strived for lies far behind it, in Paradise. In *Valerius Terminus* (1603), Bacon developed his vision, later advanced further by Major, of progressing to Adamic knowledge of nature by means of a futuristic furore, and to regain Paradise through progress.[119] Thus the "nowhere" of the Island of Bensalem is transferred to an indefinite place in the future whose paradisiacal roots lie in the past. The automatons as well as the homunculi and animal and plant breeds mentioned elsewhere fill this vision with life. These works, which go beyond existing creation, are to be perceived as elements in a historically and systematically interminable process.[120]

THE PLAYFULNESS OF NATURAL HISTORY

Francis Bacon's Definition of the Kunstkammer

I t was not just by chance that "Salomon's House" in Bacon's *New Atlantis* was conceived of as an ideal model for a *Kunstkammer*. In the preface to his unfinished *opus magnum*, the *Great Instauration*, Bacon described the elements of his life work on natural history as though he were ordering the objects of a collection *(congeriem)*: "Next, with regard to the mass and composition of it: I mean it to be a history not only of nature, free and at large (when she is left to her own and does her work her own way),—such as that of the heavenly bodies, meteors, earth and sea, minerals, plants, animals,—but much more of nature under constraint and vexed; that is to say, when by art and the hand of man she is forced out of her natural state, and squeezed and moulded. Therefore I set down at length all experiments of the mechanical arts, of the operative part of the liberal arts, of the many crafts which have not yet grown into arts properly so called... seeing that the nature of things betrays itself more readily under the vexations of art than in its natural freedom."[121] Bacon uses this central passage to define his literary work as a kind of ficticious *Kunstkammer*. The elements of nature, free and at large, correspond to the *"naturalia"* of the *Kunstkammer*; the objects of nature that have been constrained and molded by human artistic means are essentially the *"artificialia,"* and the means of altering nature come close to the *"scientifica."* At about the same time as the categorization of the collection of Rudolf II in Prague according to *naturalia, artificialia*, and *scientifica*, Bacon based his "collection" of knowledge of nature on a similar system of ordering.

This similarity was obviously based on precise knowledge of the *Kunstkammer* or at least the principles used in their organization. Bacon's treatise on travel, included in his *Essays*, ends with a list of attractions with "cabinets and rarities"[122]

that he considered definitely worth seeing. One of his earliest visions of utopian learning was significantly influenced by the concept of the *Kunstkammer*. When in 1596, Bacon expounded on his concept for comprehensive changes in knowledge and research before Queen Elizabeth I, he spontaneously thought of a *Kunstkammer* with laboratories, similar to the Uffizi *Tribuna* or the Prague *Kunstkammer* of Rudolf II, as well as the external counterpart, such as the gardens conceived by Palissy. In the words of a "Second Counsellor," Bacon attributed a *Kunstkammer*, complete with a laboratory, with the character of a philosopher's stone. He suggests "four principal works and monuments," the significance of which was comparable to, for example, Caesar's calendar reform. First, a library of hand-written and printed writings of all times and all peoples, and second, a large, well-tended garden in which all the sorts of plants that come from the sun and are bred by human hands can flourish. This also includes a zoo built around the garden, with strange and rare animals of the air, the land, and the sea. The fourth work is described by Bacon as "such a still-house, so furnished with mills, instruments, furnaces, and vessels, as may be a palace fit for a philosopher's stone."[123]

This laboratory should be seen as an annex to the *Kunstkammer* mentioned as the third site: "The third, a goodly huge cabinet, wherein whatsoever the hand of man by exquisite art of engine hath made in rare in stuff, form, or motion; whatsoever singularity chance and the shuffle of things hath produced; whatsoever nature hath wrought in things that want life and may be kept; shall be sorted and included." It is not problematic to refer to objects created by means of human skill as works of mechanical art. However, not only the definition of natural objects that have been formed by "singularity chance" remains mysterious, but also those "things that want life" and permanence. It is all the more important to clarify Bacon's meaning here, since the questionable concepts lead into the very core of Bacon's understanding of nature, art, and the *Kunstkammer*.

Resting, Erring, and Constrained Nature

In 1605, in the *Advancement of Learning,* Bacon divided the "history of nature" into the "history of course," which proceeds in normal fashion, "history of erring or varying," and "history of nature altered or wrought." The first is a description of species as they were created; the second, of deviations in these species; and the third is the products of artistic, technological processing of natural materials: "history of Creatures, history of Marvels, and history of Arts."[124] The first category encompasses all "creatures," i.e., all species and objects within the mineral, vegetable, and animal kingdoms in nature. As a perpetual repetition of God's gift of creation, this group has no evolutionary history.

The second class as well signifies no major break with a static view of nature. Pictures occurring by chance such as the natural works of art included in Aldrovandi's *"Musaeum Metallicum"* are very much in keeping with such a view (figs. 4, 20). Bacon might also have had cases in mind like that of the much treasured fur-covered man, Pedro Gonzales, whose portrait was included in the *Kunstkammer* at Ambras,[125] or of Gonzales's son Arrigo, who was sent to the Roman court of Cardinal Odorado Farnese a year before Bacon developed his *Kunstkammer* vision, and of whom Agostino Carracci later made a portrait.[126] Both played an important role in Aldrovandi's *"Monstrorum historia."*[127] Such "errors, vagaries, and prodigies of nature," as Bacon referred to them in 1620 in *The New Organon,* confirm the validity of the Six Days Work insofar as the aberrations are seen as exceptions to the rule, which in turn allows a more specific definition of the rule in light of the aberrations.[128] Nevertheless, these special cases are the embodiment of an urge for evolution. Although they do not comprise species in and of themselves, they attest to nature's striving for its own development, and even if they remain monstrous, they verify the condition for all evolution via the interaction of time and chance of which they are evidence.

Human art *(ars)*, the third class in natural history, should not be understood as the fine arts in a modern sense, but as handcraft, skill, art and technics in the comprehensive sense of the Greek *techne*. It illustrates the products of nature's metamorphic urge. In *The New Organon*, Bacon expounded that the shift from the second to the third class, that is, from the "miracles of nature" to the "miracles of art," does not take place as a qualitative jump, but rather as a smooth transition: "For if nature be once detected in her deviation, and the reason thereof made evident, there will be little difficulty in leading her back by art to the point whither she strayed by accident; and that not only in one case, but also in others."[129] Since the aberrations in the second class of natural history transmute arbitrarily into thousands of different forms, they must be subjected to constraints by art.[130] This clearly shows how Bacon perceived those products of art in his 1596 *Kunstkammer* vision which "want life and may be kept:" "For like as a man's disposition is never well known till he be crossed, nor Proteus ever changed shapes till he was straitened and held fast; so the passages and variations of nature cannot appear so fully in the liberty of nature, as in the trials and vexations of art."[131]

By giving human *ars* a place in the process of natural history, Bacon did not strive to have nature find its culmination, but to recognize the essence of nature through artistic skillfulness. Since "the *artificialia* and the *naturalia* differ neither in form nor essence, but solely in the means of their creation,"[132] the *"historia artium"* is not merely an integral, inseparable part of natural history, but can even be regarded as its epitome: "We have specified with purpose that the history of the arts shall be an adornment of natural history."[133]

The decisive step is the coming together of monstrosities and works of human skill. The aim of such an effort *(Finis huiusmodi operis)* can be seen in two strategies, according to Bacon. He hoped that new examples would serve to lay new groundwork for the sciences; by the same token, he was convinced that "… from the wonders of nature [it] is the nearest

intelligence and passage towards the wonders of art: For it is no more but by following and as it were hounding Nature in her wanderings, to be able to lead her afterwards to the same place again."[134] The aberrations of nature appear in this context as experiments which have failed, as "errors." Through art, new "trials" are allowed. *Ars* helps the monstrosities formed by nature's experiments to become successful examples of perfect form. Nature had not yet had a fixed direction because like Proteus, it had metamorphized too vaguely in too many directions; now, however, controlled and directed by artistic skill, nature could be productive by further developing itself.

Creation as a Game

The second class of natural history played a significant role in establishing the historical development of nature. In a strange way, the inexhaustible changes that nature was capable of fed on the playful impetus through which nature itself was created. Creation was not only a product of a mechanic-God, but also the work of a playful demiurge who celebrated divine wisdom, in the words of Solomon: When God created heaven and earth, "I was by his side, a master craftsman, delighting him day after day, ever at play in his presence, / at play everywhere in the world, delighting to be with the sons of men."[135] This possibly reveals a double misunderstanding; the meaning of the Hebrew *mitsaheket* is more like "joke" or "laugh," and in the vulgate *"ludens"* was probably originally intended to mean "joy," rather than "game or play:" *"Ludentem, dicit gaudentem."*[136] Ever since the Renaissance, however, the predominant interpretation of *"ludens"* has been "playing." This interpretation was probably influenced by the fact that Plato had characterized human beings as "wire puppets" that had to recognize they were "contrived to be a plaything of God."[137] It was thus

obvious to Jesuit physicist Kaspar Schott that "God the creator of Nature playeth on the earth."[138]

Pliny the Elder's *"naturalis historia"* laid down the interpretation that part of this creative playfulness was to be seen in the aberrations and "wonders" of nature. He considered these peculiar forms to be evidence of nature's urge to create fantastic creatures in all of nature's kingdoms "as a game."[139] Out of these considerations, Leone Battista Alberti and other fifteenth century theorists developed the assumption that the total potential of all art forms lay in the freely forming chance images of nature.[140] At the same time, Nikolaus von Kues (1401-1464) developed this image into a model of human knowledge *per se*. In the introduction to his work *De ludo globi* ["Of the game of the globe"], Kues wrote of reverting to play—which Plato saw as the sublime form of thought[141]—aware of its limits and possibilities, ever searching, yet never reaching the center. Kues stated "that no decent game is entirely lacking in learning material. And this pleasurable exercise with the globe represents for us, I believe, a philosophy of not small proportion."[142] The game Kues describes involves throwing balls that are partially hollowed out, so that their shifted centers of gravity give rise to spins and unexpected movements. Kues succeeds in combining the demiurge motif of a wood-turning God with the playful character of creation.[143]

The same principle applies for Bacon. He has been interpreted as the early ideologist of a mechanistic "cold" exploitation of nature directed at purely practical thought. But this does not acknowledge the fundamental significance of the *"ludicrum"* in his version of the human capacity for art and knowledge.[144] Not only did he characterize the aberrations of nature in *The Advancement of Learning* as products of time and chance; he also regarded human playthings as extremely valuable, as he stated in *The New Organon:* "Again, as instances of the wit and hand of man, we must not altogether contemn juggling and conjuring tricks. For some of them, though in use trivial and ludicrous, yet in regard to the information they give maybe of much value."[145]

Bacon's argumentation, at least in terms of its concepts, is in keeping with the works of Rosicrucian Michael Maier, such as his *Lusus serius*,[146] written in London around 1617-18, and the "serious jokes" of the paintings of Giuseppe Arcimboldo.[147] The epistemological esteem he attributed to the monstrous "aberrations" might also have been encouraged by the fact that the French doctor Ambroise Paré referred to them in *Des monstres et prodiges* (1573) as a game of nature *("s'y est jouee")*, which should attest to their greatness.[148] The playful fashioning of natural materials as a further development of the form principle of natural metamorphoses was a definitive finding for Bacon: "Hence it is that all the discoveries which can take rank among the nobler of their kind have (if you observe) been brought to light, not by small elaborations and extensions of arts, but entirely by accident."[149]

The Kunstkammer as a Playroom

The idea of nature at play, attempting to playfully emulate the human mind, yet also needing to confine and constrain it in order to comprehend the essence within the arbitrariness of chance, required an appropriate vehicle with which to bring together these harnesses of nature's fantasies on a large scale and as completely as possible. The *Kunstkammern* were seen as an ideal place where Nature the Player could be observed and at the same time a place in which nature could be faced with limits and given direction. This was clearly expressed in Johann Andreae's *Christianopolis*, an island utopia published in 1619 in Strassburg. Francis Bacon was familiar with this work and it served as a model for his own *New Atlantis*.

Andreae's utopia was also based on the form of knowledge demonstrated by the *Kunstkammer*. In *Christianopolis*, a city is described whose buildings harbor a perfected empirical, alchemical, and mechanical system of natural sciences and

humanities, with numerous laboratories and demonstration rooms. It also includes an idealized *Kunstkammer,* foreshadowing the 17th century academies.[150] The notion of games is incorporated as perhaps the most significant element of creative fantasy. As early as in *Chymische Hochzeit,* ["Chemical Wedding"], Andreae referred to his work as *"ludibrium"* and in the introducton to *Christianopolis,* he called his work a *"ludicrum."*[151] "Play" is also the determining factor behind central elements of this society for research and learning. In the "natural science hall and laboratory," in which creation in all its species and manifestations is painted on the walls, "even boys at their play [are] recognizing, naming, and investigating...."[152] Corresponding to the significance of pictorial art, the practice of which gives one "eagle eyes," there is an art academy with not only workrooms, but also pictures and statues of famous men, and study materials for a variety of activities: "Architecture, perspective, methods of pitching and fortifying camps, and even sketches of machines and statistics" are all parts, or rather comrades, of pictorial art. "Whatever of the dramatic spiritual things have, or whatever else there may be like literary elegance, it can all be seen here, purposely prepared for scholars."[153] The statement is no less definitive with respect to one of the central laboratories: "Here the properties of metals, minerals, and vegetables, and even the life of animals are examined, purified, increased, and united, for the use of the human race and in the interests of health. Here the sky and the earth are married together; divine mysteries impressed upon the land are discovered; here men learn to regulate fire, make use of the air, value the water, and test earth. Here the ape of nature has wherewith it may play, while it emulates her principle and so by the traces of the large mechanism forms another, minute and more exquisite."[154]

Andreae's allusion to the symbolic ape who emulates man, as human skill emulates nature, most likely traces back to the magnificent story of the macro- and microcosm of the English Rosicrucian Robert Fludd that appeared in 1617 in Oppen-

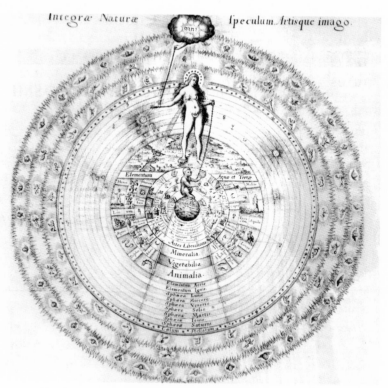

Fig. 30: "Mirror of all of Nature and Picture of the Arts"
Etching by Matthäus Merian,
Illustration in: Robert Fludd, Utriusque cosmi ... historia, 1617

heim. On the frontispiece by Matthäus Merian, under the heading "Mirror of all of Nature and Picture of the Arts", an ape is shown sitting on the earth. His left hand is chained to the personification of *natura*, who is rising up to the empyrean, herself bound to the hand of God. In addition, in his left hand, the ape is also holding a small orb which he has made himself. He is measuring this globe with a gesture of *"deus geometer"* (fig. 30).[155] Kaspar Schott also alluded to this figure in his reference to artistic, technological creations as products of the ape of nature: "And art, or the ape of nature, has devised so many ways of showing such a diverse, funny, wondrous strange Theatre."[156]

The high regard of playfulness corresponded to designs in contemporary books on machines which were to some extent deliberately nonfunctional or else primarily served no purpose. In the preface to Besson's 1578 mechanics book, he spoke of *"vtilitas and delectatio,"*[157] (use and enjoyment) and in de Caus's dedication to the King of France, he referred to the "powerful movements" as a collection of "partly useful / and partly enjoyable machines."[158] Usefulness on the one hand, and play *and* usefulness on the other, also characterize social distinctions. In 1684, Kircher justified his "New Art of Sound and Tones" by explaining that "the scholarly world and those who know art / those eager for science will have some utility; whereas princes and lords will get both pleasure / and a useful and functional purpose."[159]

The demand for playfulness and lack of purpose helped to keep the balance between application and basic research, pleasure and purpose, freedom and a fixed function; this saved natural history from ultimately ending in pure usefulness. For Andreae, the artistic character of divine reason and its emulation virtually forbid doing research in *Christianopolis* that focussed solely on its usefulness. "They do these things not out of necessity, but with the intention of continuing the artistic competition, … so that reason, or much more the divine inspiration still within us, shall be able to shine splendidly from within every material available to us."[160]

Playful pleasure in artificial creation not primarily guided by usefulness was thus associated with godlike elements. By the same token, the urge to collect in order to form one's own world in miniature was attributed the character of emulating divine playfulness. In order for the demiurge to be able to become the absolute God, he had to create something playful and lacking any use, since having followed any purpose whatsoever would mean having acted as an agent of a higher power, performing a given task. Humanity could only become a true emulation of God when having attained the highest category of play. According to the image of the *"deus ludens,"* the collector, in comprehending the creative process, preserved the

reciprocity of useful application and lack of purpose, in order to gain knowledge "while at play." Just as the earth was viewed as the *"Kunstkammer* of God,"[161] the collector also created—as physician Pierre Borel described his own, significant *Kunstkammer*—"a world in a building, indeed a museum, which is a microcosm and a compendium of all extraordinary things."[162]

The apparent disorder of the collection items reveal their philosophical significance within this framework. The collection of the *Museo Cospiano* in Bologna, whose inscription conceptually supported the notion of dividing the historical chain into four links (fig. 22), could lead to the expectation that the arrangement of the objects would reflect this scheme. Corresponding to the short text, the display cases do include objects from all the kingdoms of nature, small sculptures from antiquity as well as contemporary statuettes, and weapons and tools. It is all the more surprising that they are not separated from each other by any recognizable structure. Coral, for example, which combines all three kingdoms of nature, are mixed with ancient vessels for oil and small statues, coins, prepared specimens and utensils; although samples are chosen from the four categories of nature, ancient sculpture, post-antiquity works of art, and devices, they are not separated from one another and are instead allowed to mingle together. They are apparently combined in such a way as to play down the boundaries between them and, as *Kunstkammer* theorist Johann Daniel Major expressed a short time later, in reference to the *artificialia* in his own collection, so they can appear to be "in a scattered / deliberate disorder."[163] The arrangement of the genera did not serve to separate the various areas; instead, it built visual bridges in order to emphasize the playfulness of nature through the associative powers of sight. The catalogue thus refers numerous times to the "jokes" of nature.[164] The same is true for the inventory catalogue of the *Museum Wormianum*, which stated that "Nature was at play in all her external manifestations of natural things."[165] The largest *Kunstkammer* of the

17th century, the "*Kircherianum*," was also regarded as a place in which Nature the Player could be viewed.[166] When Bacon, in his 1596 vision of a *Kunstkammer*, referred to natural objects arising by chance "that want life and may be kept," he had both the unconstrained game of nature and the constraints of art in mind, through which to determine the direction of the never-ending metamorphoses.

Bacon's notion of having human art represent the epitome of natural history is an attempt to examine nature's capacity for the greatest possible variation, thereby venturing on to the center of *natura naturans* (nature-engendering nature) and the *fons emanationis* (source of emanation) of all natural bodies.[167] This is generally interpreted as the desire to plumb the depths of the not yet exhausted possibilities of the *physica sparsa* (physics of diversity), *without* exceeding the possibilities intended from the very beginning within the framework of creation and forcing natural history to fit into a historical evolution. However, the impact of the *Kunstkammer* supports interpretations which do not see Bacon's search for nature-engendering nature as a game played with that which already exists, but rather as breaking out into a new creation and thus into the historicity of nature.[168] The collision between a static sense of nature created only once and the historical refinement of natural materials turns the classical conflict between *natura* and *ars* into a point of friction caught between stillstand and development. The history of artistic and mechanical skills dissolve the descriptive, persisting natural history from the inside out, by revealing the essence of nature's changeability and "imitat[ing] also motions of living creatures, by images of men, beasts, birds, fishes, and serpents."[169]

Such objects were primarily lacking any use, insofar as they served as playthings; however, it is precisely that lack of purpose in their independent movement which emphasized the demiurgic nature of their production. An automaton which might have originally belonged to Karl V and is now in the possession of Munich's Deutsches Museum clearly illus-

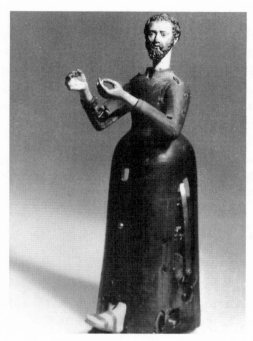

Fig. 31: Automaton, ca. 1560,
Munich, Deutsches Museum

trates why Bacon had such high regard for androids and why autonomously moving machines were collected in *Kunstkammer* with such a passion (fig. 31). Anyone having seen the figure move was enchanted by its magic. It repeatedly paces out a rectangular area, whereby its foot movements make a powerful, clattering sound. In an incredibly complex, simultaneously timed design, the hands perform circular movements as if the automaton were saying a rosary, while the head bends forward and to the side in a series of steps and the mouth opens at the beginning and end of the different phases; even the eyes move back and forth unceasingly.[170] Such automatons are products of a development, and since there is no categorical difference between works of art and elements of nature, it is conceivable to view nature as historically changeable.

Although nature's urge to evolve can be regarded as analogous to a revolution in knowledge that takes place retroactively rather than linearly, and in an intentionally fragmentary method aware of the significance of chance, rather than in operational certainty, this does not represent a Darwinian form of goal-oriented evolution. It is more likely an intermediate stage, between the Christian-Aristotelian notion of unchanging species and the historicization of nature that approaches Darwin's theory of evolution.[171] The most significant contribution of the *Kunstkammer* to the *Advancement of Learning* is perhaps its preparation of a history of nature. The splendor of its objects—from natural ones to the most refined—turn the kingdoms of nature into mediums of artistic activity which perceive the essence of nature as a process. The continuum which started from natural history and developed through Aldrovandi's "*Musaeum Metallicum*," Mercati's "*Metallotheca*," the collector portraits of the Earl of Arundel and the official portrait of Mazarin, involves movement that culminates in artwork and machines and thus finds an impulsive power in playful chance. The simulation of nature depicted in the "rystique" style, the torque of the sculptures, and the independent movement of the automatons thus all demonstrate an almost demanding character in addition to their natural philosophical meaning. In one of the most impressive statements of *The New Organon*, Bacon warns of narcissistic stagnation. Works of art, which are more transparent than wonders of nature, could lead one to premature contentment: "For there is danger lest the contemplation of such works of art, which appear to be the very summits and crowning points of human industry, may so astonish and bind and bewitch the understanding with regard to them, that it shall be incapable of dealing with any other. . . . "[172] Bacon could have similarly admonished a nature that had to become static and unchanging in the eyes of traditional natural historians, since, as a product of an already completed act of creation, it is satisfied with its existing state and therefore knows only the cyclical repetition of the species, and

is not an escape from this type of ahistoricity.

Bacon's sense of the historicization of nature hinged on the condition that there was no essential opposition between natural and artistic form. As with natural history, the visual stimulus of the *Kunstkammer* allows no fundamental distinction to be made between natural and human works. The collection becomes a gigantic vessel of a nature which does not perceive man and his work as an exception, but as an integral component of a greater whole. The training of the historicizing eye that had been practiced for several generations provided the visual background to support this realization. This view evoked the chain of collection areas: **Natural formations – ancient sculptures – works of art – machines.** Bacon considered nature and mechanics as integral parts of natural history. In the sense of honoring a *"prisca theologia,"* Bacon was convinced of the wisdom of Greek mythology, despite his belief in future technology and the natural sciences.[173] When the exclamation "the resurrection!" slipped out of his mouth when a new delivery of ancient statues for the collection of the Earl of Arundel (fig. 10) arrived, this might also have been motivated by the fact that these were the earliest evidence of a bridge leading from natural aberrations to history, that is, of efforts to control and mold nature's seething will to evolve.[174]

Bacon's historicization thrust could not be viewed in isolation, since the *Kunstkammer*, his source of inspiration, spanned all the kingdoms of nature as well as art technology. This brought not only the history of the earth, but also that of the species and human skill within the horizons of historical change. By explaining the historical development of the arts by tracing the fine arts of *"historia civilis"* back to political and natural conditions, Bacon formulated a methodological credo that was not to be taken up again until Johann Joachim Winckelmann.[175]

The impact on a series of geological and fossil researchers was more constant. As was the case with Bacon, ideas of evolutionary history found a way into their thought—despite all

the contrasting ideas of the validity of the Biblical Six Days' Work—whenever they attempted to trace human skill and technology back to nature. This was true for the Danish researcher Niels Steno, whose studies dealt with the writings of Bacon, among others, and who was able to visit the Danish, German, French, and Italian *Kunstkammern*, even having the opportunity to study the manuscript of the inventory catalogue of Mercati's *"Metallotheca"* (fig. 7). Steno started his own collection, which was then added to that of Grand Duke Cosimo III de'Medici of Tuscany in 1675, as Steno had been commissioned to prepare an inventory of that collection. His own objects represent an archive of his journeys through Tuscany. Steno's scientific findings were published in 1669 as a "precursor of a dissertation on solid bodies that are enclosed within other solid bodies by nature." Therein, in a more radical manner than Bacon, he does not see the earth as a body with a potential urge toward evolution, but as an object that has already undergone a long evolutionary process.[176]

A short time later, British natural history researcher Robert Hooke developed the idea, based on fossils, "that it is very difficult to read them, and to raise a Chronology out of them, ... yet 'tis not impossible."[177] Steno had had the chance to get to know Hooke, who was also familiar with Bacon's works. Hooke very convincingly confirmed the relationship between the first two links in the chain **Natural Formations – Ancient Sculptures – Works of Art – Machines** by comparing fossilizations to monuments of antiquity. He understood the two as clearly separate, yet at the same time related parts of a history which spanned from natural formations to the most ancient evidence of antiquity: "Now these Shells and other Bodies are the Medals, Urnes, or Monuments of Nature." According to Hooke, it was the task of the researcher to determine when they were stored in their natural repositories, for "[t]hese are the greatest and most lasting Monuments of Antiquity, which, in all probability, will far antidate all the most ancient Monuments of the World, even the very Pyramids, Obelisks,

Mummys, Hieroglyphicks, and Coins, and will afford more information in Natural History, than those other put altogether will in Civil."[178] The earth itself was thus perceived as a gigantic *Kunstkammer*-like container which could also be understood as a historical archive.

At about the same time, Thomas Burnet also concluded the historicity of the earth on the basis of the progress of the arts, in his sensational *Theoria Sacra Telluris*. According to the 1698 German translation of his work, some agree with Aristotle that "it is eternally the same and without a beginning; not alone on account of the material / but also that which concerns its form / buildings / apparatus and decorations; / namely, / humanity has eternally existed on earth / animals / trees and herbs / minerals /sea / mountains / islands / fire / air / and other complete and separate things; and these did not first come of their beginnings and foundations of these." In a sort of forward defense against champions of the Biblical doctrine of creation, Burnet continued that no interpretation was more "contrary to Christian faith." In addition, however, there is no possible way of bringing this view into agreement with "natural reason." It would be just as nonsensical as the assumption, "that the houses / temples /altars / and palaces, with all their equipment have also existed since eternity. It is forsooth implanted in the human dispositions / that they imagine in the things, original existence and composition, an order / and the simple things for the first / and what exists from combining those things / as the first to have sprung from them. So it comes from Nature itself / that a many-formed composition or a multiple of parts / and the complex thing made by combining them are not the same / although always and necessarily of the same form.... The external form and fashion of nature / as it can be seen today / has also many characteristics of a new thing / that is so civil – as natural order of things / which the authors now and again take notice of."[179] For Burnet, as well as for Bacon, the history of skillful technology and the arts is both proof of and the model for a history of the earth.

Nevertheless, again and again Steno and Burnet have been declared to be evidence of a philosophy of nature caught in cyclical thinking. This rather conservative assessment can be supported at least insofar as the *Kunstkammer* and the impetus to historicize nature given by Bacon's view of natural history did not represent a direct precursor of 19th century evolutionism. On the other hand, however, the recently formulated theory that Steno and Burnet continually let "time's arrow" end in "time's cycle," so that they could be regarded as the stark opposite to the Darwinian concept of contingent history, misses the point.[180] Impressive statements have been made from Bacon to Burnet that approach evolutionary thought. It is thus not only too sketchy to describe such a counter argument to Darwin, it also misses the heart of the conflict. The issue is not that "time's arrow" again and again resorts to cyclical thinking, but that its direction does not have a clear goal and above all, that it rushes through only partial segments of natural philosophy.

This represents a miniscule shift in the hypothesis, yet it is fundamentally essential for the evaluation. The answer is to be found in the disparity in the cognitive faculty of image and word, eye and handwriting. Images generally precede language and those areas of thought conveyed linguistically. The conflict between a static and an evolutionary view of nature is thus at the same time a conflict between the shocking unfamiliarity of the visual autopsy and the courage to let this impression into the control room of language and concepts. Bacon, Steno, and Burnet are modern to the extent that they trust the objects of the collections and art theory more than the theological and natural history tradition and because they know how to express this intuitive certainty in particular areas. In the total framework, however, they do not go beyond the horizons of the theology and natural history which had been established by language. The mental capacity of the pictures forced them into an intermediate position between esoteric images and exoteric language.

80

TWINS OF PROGRESS

Utility

The eighteenth century changed the frame of reference. At the same time as the historical chain connecting natural objects and machines—as was demonstrated by the *Kunstkammer*—was broken down into its individual links, the model of playfulness was projected onto other fields such as probability calculus or Immanuel Kant's concept of *"Phantasie."* Friedrich Schiller's idea of humanity depicted only those as true individuals who could *play* between the poles of material change and perfected immutability; this concept alone demonstrates how the complexity of the old theory of play was continued.[181] Because the *Kunstkammern* broke down into their individual components, their claim to encyclopedic knowledge lost its foundation. The idea of a physical archive of materials of the entire world was first resumed with respect to a partial area of the broken-down continuum. The motivating force behind this development was the rise in utilitarian thought.

At the close of the sixteenth century, the Parisian humanist Petrus Ramus found both England and Germany to be praiseworthy with regard to their respective scientific advancements, but he considered Italian mathematics and its application, and its promotion at various academies, to be incomparable.[182] On the other hand, Gottfried Wilhelm Leibniz made the following statement in 1671 justifying the establishment of an academy of the arts and sciences in Germany:

> Italian works of art consisted almost solely of the formation of lifeless, still-standing and purely aesthetic things. The Germans, on the other hand, were for all time busy producing moveable works that satisfied not only the eyes and the curiosity of great men, but also performed a task, subordi-

nating nature to art and able to make human work easier. And it is remarkable that a so ingenious nation would leave the glory of the living arts to a nation it considered much darker and was content to deal with their dead proportions and architecture. Thus I can justifiably tell the truth that Germany, and in particular Augsburg and Nuremberg, is the mother of invention, both weight and spring clocks, the ever powerful, admirable fireworks, even of the air and water arts.[183]

The then twenty-four year old had no idea that he was describing not something that was valid "for all time," but a relatively recent judgment. The difference between the ideas of Ramus and those of Leibniz lay in the utility of technological inventions that was definitively responsible for the separation of art and technics, of the high regard for the antiquity and the natural sciences, as well as for the emerging arrogance toward Italy. Although according to Leibniz, Albrecht Dürer had also dealt with "lifeless proportions," this activity "was also utilitarian and clearly intended for the daily use of tradespeople."[184] The compulsion for utility created a geographic split in addition to the separation of technology and art. Thought in terms of purpose was thus established in Germany and activity with art cleansed of the realm of stark necessity remained in the apparently "dead" terrain of Italy. Within the same context, Leibniz supported the establishment of a huge research facility structured according to the principle of the *Kunstkammer*. It would also include "curiosity and rarity cabinets," that is, a *"theatrum naturae et artis,"*[185] but from this point on, the arts were ranked according to their degree of usefulness.

A decade later, this process was also fueled by historical theory. *Parallèle des Anciens et des Modernes* by Charles Perrault, which appeared in four volumes between 1688 and 1697, proclaimed the superiority of modernity as compared to antiquity. It was argued therein that there was no precedent for more recent inventions in the natural sciences and the area of production, and that these, by emulating neither antiquity nor

nature, imitated the demiurgic god.[186] That signalled the breaking away of the fourth link of the historical chain of nature, antiquity, art, and technology from the three earlier elements, to deem them not equivalent elements of a successive progression, but rather to subject them to the authority of the efficiency of purpose. When Cellini's moveable sculptures scored a victory over the statues of antiquity in the mid-16th century, it was a triumph in the paragon, that is, a competition between equivalents within the arts. Now, however, value standards from beyond the arts were able to prevent a nonhierarchical competition.

A new stage in this process was reached in Germany when the Saxon engineer Jakob Leupold, in describing the *Kunstkammer* in Dresden belonging to August the Strong, ruler of Saxony, offered praise in his epoch-making book on mechanics *Theatrum Machinarum Generale* (1724), that denied the playful foundations of the *Kunstkammer:* "A both exquisite and highly respectable collection of all artistic, rare, and wonderful things, of both nature and art, such as would be difficult or impossible to find in any other kingdom, for the reception and promotion of the arts and sciences, and in particular for the use of the country." He sharply attacked the artistic, mechanical game that had comprised the epistemological essence of the *Kunstkammer* one hundred years earlier as "foolish stuff" of "windbags:" "And daily still there are many new artists and masters of invention who know how to create nothing but new wonder works...; even perpetual motion is like nothing to them."[187]

It was in this same spirit that Friedrich Gottlieb Klopstock was snubbed in 1765 for soliciting support for the foundation of a German academy at the Viennese court. The voice of an artist did not count, "since the fine arts are seen as a thing of luxury and opulence, to which one would return, should there be nothing better to do."[188]

And finally, the judgment of the fine arts approached the level of ridicule in the systematic "instructions for technology,"

by the untiring Cameralist Johann Beckmann. Beckmann's work first appeared in 1777 and represents the basic writings of German mercantilism. In it, he admonished that the praise of the "so-called fine arts, for example, painting, sculpture, gem cutting" was so exaggerated "that for a period of time, knowledge of the arts was acknowledged only by the great ones and scholars, until it was finally appreciated that a state has first to seek the necessary and useful and then the beautiful, or at least both are to be sought with the same zeal. The fine arts are students of opulence, and this arises from those trades that were formerly scorned."[189] This also announced the conceptual unity of art and mechanics. Fully aware of the epochal nature of the break he described, Beckmann wrote that he "dared to use the term technology instead of the expression art history, which had been commonly used for quite some time. Art history is at least just as incorrect as referring to nature study as natural history. Art history might include the explanation of the invention, the progress, and the additional fate of an art or a trade; but technology means much more; it completely, clearly and systematically explains all works, and their consequences and causes."[190]

This splintering led to the elimination of every trace that ancient art had ever occupied a position in the course of natural history, and that it did not stand in contradiction to modern machines, but was understood as a challenge and a stage in a progression. The attention given to foreign methods of production was more important to Beckmann than the admiration of the ancient art of Italy. If a traveler were to become familiar with the situation of the trades in Germany, and compare it with foreign inventions, "he would see more in Italy than the guide could ever show anyone who would pay him, and even more than just the ancient works that have been seen and described by so many... Then German coins would be carried away, but also foreign knowledge brought in, and the question would still exist, who had paid more, the German or the foreigner."[191]

*Fig. 32: Pendulum clock by Henry Bridges, 1734,
Copper engraving, Paris, National Library*

On the occasion of his first journey to Italy in 1786, Goethe
gave support to the aptness of this opinion all the more, as he
did not share Beckmann's petty manner of comparison. Goethe
was so convinced of the outstanding worth of the fine arts and
the sculpture of antiquity that he regarded their admiration as
a departure from an epoch. "On this journey," Goethe hoped,
"I wish to calm my soul with the fine arts; to let it be forever
impressed with their sacred image and to preserve it for silent
enjoyment. Then I wish to turn to the tradespeople and when I
return, I wish to study chemistry and mechanics. For the time
of the aesthetic has past; now only necessity and strict need
make demands of our days."[192]

The triumphal march of useful industry, which also existed as a struggle for a high standing in modernity, had found its monumental culmination in a pendulum clock more than three meters high, made in 1734 by the English architect Henry Bridges (fig. 32).[193] In the form of an ancient temple, it was filled with internal mechanisms of the most modern form, and was sent round the world as a "demonstration model of the world" and as a herald of having surpassed antiquity:

By arts Mechanic you will here be tought
More than Rome knew, or Grecian sages thought.[194]

Socialization

By the middle of the 18th century, mechanics was conceptually and actually disengaged from the realm of the tradition of antiquity and art. This had revolutionary consequences on the collections. The *Kunstkammer* had provided a plateau on which to record the complexity of the chaos of the world and display it in both its spacial and its temporal layers. When this platform collapsed, the *Kunstkammern* were replaced by special collections of natural objects, ancient sculptures, works of art, and machines. The *Kunstkammer* in Dresden started being dismantled in 1720, representing the beginning of the development which ended up claiming all the important *Kunstkammer* within the course of the 18th century.[195]

The trust in visual discoveries that had formerly filled the playful plateau of the *Kunstkammer* with life and concepts now seemed like an unrelenting source of division. Since the similarities between species had been determined visually, associations that went beyond narrow limits with respect to relationships between objects were missing. After many generations of categorization according to the visual school, for the first time around 1630, the documented, style-critical categorization of painting styles[196] now, one hundred years later, became explo-

sive for the *Kunstkammer*. This new categorization system connected natural history, which for Bacon had still been responsible for the overlapping relationship between human works and those of nature, with the means of visual categorization and exclusion.

The most important natural historians of the 18th century, George Louis Leclerc Comte de Buffon and Carolus Linnaeus provide clear examples of the complexity of this procedure. Buffon continually referred to the significance of the visual autopsy and the training of the eye in collections. His description of the royal collection of *naturalia* stressed the fact that nothing is more successful "in promoting the growth of natural history than the consistent viewing of natural things which comprehend that natural history." Such viewing aimed to determine the inner connections between groups and species by recognizing similarities, and to form related groups in this way, the essence of which would separate them from that which is different, but follow similarities in order to implant the structural laws of nature in one's memory: "When these characteristics, as far as they show similarities and differences, are then compared with one another, they present the image of nature to the mind and impress them into memory."[197] In view of the unfathomable number of natural products, Buffon wrote that it is necessary to place samples together in collections so that one has the entire range of diversity "before one's eyes." The greatest discoveries come from an unbiased view in search of precisely recorded similarities and relationships: "When one becomes more familiar with these things, when they are viewed often and, so to speak, without intention, then they gradually begin to make certain lasting impressions upon us that link them thereafter in our minds through firm and unchanging similarities with each other.... One must therefore begin by viewing many things, and viewing them over and over again."[198]

Irrespective of this appeal to view things in an unbiased, ordering manner, Buffon's expansive literary style and his

fluctuation between description and pragmatics contributed to criticism of his theories as representing an outdated, aristocratic view of nature. At the same time that cabinets of *naturalia* were regarded towards the end of the 18th century as dust-filled "storage closets," Buffon was reproached in the 19th century that his greatest achievement was the promotion of such cabinets: "The lord count attempted to arouse a certain noble dilletantism among the aristocracy with his refined and pompous descriptions. In fact, it brought its best fruits for the growth of the Parisian collections." In magnificent, high-sounding phrases, Buffon described "the higher animals, mammels and birds, their customs and ways of life, without any order or interconnections, according to however he considered this or that material to be suited to bring a shine to his style."[199] This criticism of Buffon's language also attacks the supposed arbitrariness of his natural system, thus revealing its intermediate position with respect to methodology. Buffon intended to sharpen the eye, as a means no longer of discovering comprehensive associations, but distinguishing characteristics. But his attempt to combine a history of humanity with the history of nature[200] remained within the domain of the comprehensive conception of the *Kunstkammer*.

The same applied for Linnaeus. In an amazing passage in his work about his first "Tour in Lappland" (1732), which he undertook while still a student, it is obvious that he was still influenced by the way of investigation as taught by the *Kunstkammer*, that is, to make associations, springing from natural objects to those from foreign realms such as mythology. In view of the splendor of the rosemary heather, Linnaeus doubted whether "a painter is capable of transfering the grace of a virgin to a painting, and to adorn her cheeks with beauty," but on the other hand, he himself completed just that transfer process via his imagination. In view of the beauty of the plant, he thought of the poetic associations of the *image* of Andromeda: "When I saw it for the first time, I imagined Andromeda, as it is portrayed by poets. The more I thought of

*Fig. 33: Comparison of rosemary heather
(Andromaeda polifolia) and Andromeda,
Sketch by Carolus Linnaeus, 1732*

this image, the more it became identical with this plant." Linnaeus then described how the form and position of the plant corresponded to the beauty as well as the fateful situation of Andromeda, and how the environment also played a role in this comparison. The grassy hills surrounded by marshlands, with toads and similar "poisonous" animals running about, correspond to the cliffs to which Andromeda is chained while she is guarded by the dragon. Linnaeus did not stop at the poetic metamorphosis of the plant into the mythical form of a woman, however. Contrary to his statement that no artist could adequately paint the beauty of the plant, he created his own conceptual classification and a corresponding *illustration* depicting the comparison between heather blossoms and Andromeda, grassy hills and cliffs, and animals and the dragon (fig. 33): *"Andromeda / ficta et vera / Mystica et genuina / figurata et Depicta"* (Andromeda / fictional and true / mystical and genuine / imagined and depicted).[201]

In Linnaeus' scientific classification system, he named the rosemary heather "Andromeda polifolia," thus preserving the memory of this mythical image. Three years later, the luxury of an imagination in terms of pictorial associations was already

overshadowed by the clear-cut nomenclature of the *"Systema naturae,"* which denied any associative aspects. Linnaeus' simple explanation fluctuating between language and formulas started to take the upper hand with respect to the *Kunstkammer*-stronger than Buffon's concept of natural history was able to. Linnaeus, like Buffon, had incorporated the inventories of nature study museums, including that of the ruling Swedish family as well as a dissertation on the construction of natural history collections written by a student of his and certainly expressing his own thoughts.[202]

The preface to the German translation of Linnaeus' *"Systema naturae"* (1740) contains the suggestion that "perhaps some wish to organize the *naturalia* in their cabinet according to this identification framework, and the index of which according to the descriptions that appear in these tables, as in the example of one or another famous scholar."[203] In the same year, the *"Museum Richterianum"* was founded in Leipzig. It was a collection of *naturalia*, the organization of which obviously followed Linnaeus' system of classification: "An effort to have a good framework involves not only true use, which is concerned with the preservation and expansion of the cabinet, but a certain amusement, which is known only to those who spend a portion of their free time observing that which concurs in the created world.... The similarity or dissimilarity of those things that exist in great number immediately shows that it is necessary to dedicate each creature to its proper neighbor; and to socialize like with like, and to separate that which is dissimilar." "To socialize" means to create classes and subclasses of flowers, animals, mussels, etc. "according to the regulations of art" by visually checking the proportions: "An equality of thought common to all areas of scholarship; a classification system of all human tasks referred to in everyday life as prosperity and cleanliness, that which is similar to painting, the connections between all things in architecture, they are all that which is called methodology in those collections."[204]

The frontispiece of the *"Museum Richterianum"* inventory

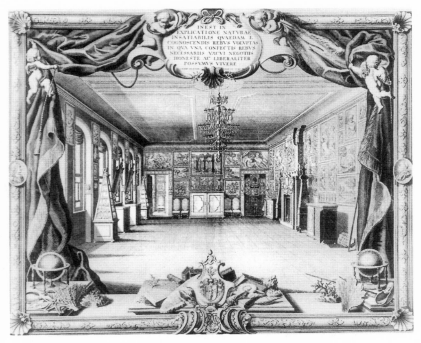

*Fig. 34: Museum Richterianum, Frontispiece in
Johann Ernst Hebenstreit, Museum Richterianum, 1743*

takes the methodological dominance of the arrangement of the pictures into account (fig. 34). Samples from the *Kunstkammer*, such as shells, coral, an ancient fragment, reliefs, globes, and books, are scattered throughout the entire room, but only the paintings hanging shoulder-to-shoulder are "socialized." This special natural history collection still includes all the components of the *Kunstkammer,* but the fine arts have been removed from the ensemble as a whole. The separation of the fine arts represents a curious process leading them to be saddled with everything that was previously demanded of the universal collections as a whole.

The Villa Albani

The Villa Albani, built in 1760 in Rome, played an incomparable role in the process of dismantling the comprehensive *Kunstkammer* that simultaneously brought an increase in the value of one of its components (fig. 35). It represents of one last great complex facilities that was in keeping both with the tradition of the villas outside the old city walls and that of the ancient Roman gardens of the Renaissance. The outstanding importance of the villa lies in its threshold character. Since it was intended from the very beginning to house the collection of ancient art belonging to Cardinal Alessandro Albani, it was regarded as the first independent museum of modernity. This was only true to a certain degree, however, since it was also residence of the Cardinal and his staff. In addition, the relationship between the garden and the buildings did not correspond entirely to the modern requirements of a museum with respect to anything but those objects in the area of the collection, so that it could just as easily be regarded as the end of an era, rather than the beginning of a new one.[205]

The sculptures scattered throughout the park as well as those exhibited in the rooms inside, together with the frescos of the villa, depict a cosmological system of organization that is specified down to the smallest detail. It was celebrated as a *sol invictus* and gave the ancient idea of Rome another cosmological interpretation.[206] The villa thus possesses a strongly conservative orientation, as was cultivated in the circle of Jesuit priest Contuccio Contucci. As one of Athanasius Kircher's successors as curator of the *Museum Kircherianum* (fig. 26), Contucci was considered a type of oracle of the study of antiquity.[207] Of course, the *Museum Kicherianum* and the villa are totally different as regards appearance. But the close relationship that the Jesuit scholar had to Cardinal Albani, and his presumed influence on the iconographic design of the villa as an *"imago mundi"* bring these closer together than appearances would suggest.

*Fig. 35: Façade of the Casino of the Villa Albani
by Carlo Marchionnis Casino (1755-1757)*

Winckelmann and Piranesi

The threshold character of the villa is apparent in its con-
trast to this cosmic veiling of the collection of sculptures of
antiquity. This becomes even more obvious since the same per-
sons responsible for developing the design of the collection
were able to impose a value judgment on ancient sculpture that
was unaffected by this integration. For Winckelmann, who
considered his friendship to Contucci "not only useful but also
very worthy of praise,"[208] this comprehensive canopy no
longer applied. As Cardinal Albani's antiquarian, Winckel-
mann was interested solely in the individual sculptures of
antiquity and how they were anchored in history.[209] His activi-
ties at the Villa Albani offered him the unique pleasure and
privilege of having the original works in one of the most supe-
rior collections in existence at his disposal, through which to
scrutinize and sharpen his view of ancient sculpture—as he

had essentially developed in Dresden. Winckelmann limited his study of works of antiquity in the sense of the "cool" view of Linnaeus to strictly stylistic criteria, that is, on appearances and aesthetically relevant aspects, in order to orient himself in the incredibly large collection—of tens of thousands—of busts, statues, and fragments from antiquity. He described and classified according to historical styles and using floral metaphors of growth, blooming and wilting of the major styles.[210]

At the same time he attributed criteria of external nature and political history to such "cleansed" objects. In his *History of Ancient Art (Geschichte der Kunst des Alterthums,* 1764), Winckelmann expanded the theory of Jean Baptiste Dubos (1719), that climate has a definite influence on the character of peoples, towards social nature. By drawing conclusions about the quality of society and art on the basis of natural and political climate, he saw classical Greek sculpture not only as a product of luck of an ideal climate, but also as the triumph of political freedom. Nature and climate offered art the best possible conditions, but political freedom was also necessary if art was not to remain weak. "But in Athens, where a democratic regime was introduced once the tyrants were removed, a process in which the people as a whole took part, the spirit of each citizen was raised, and the city itself above all Greeks.... The arts settled here with the sciences, they took their most distinguished place and from here, they went out to other lands."[211] The Rome of the emperors could not compete. Even Hadrian, who was the one most likely to be able to lead art back to its former height, was faced with unsurpassable obstacles, for "the spirit of freedom was lost from the earth, and the source of lofty thought and true glory had disappeared."[212] Besides Florence of the Renaissance, the contemporary Rome most closely approached the ideal of democratic freedom, since here and nowhere else, perceptible freedom prevailed: "a shadow of the former freedom... can still be seen in Rome, where the masses enjoy a lively freedom under the priestly government."[213] Winckelmann emphasized several times how

deeply moved he was by the Roman experience, that those who knew and loved the antique sculptures in the Villa Albani moved about as if in a realm of free exchange, without hierarchy, and then one could walk with the Cardinal "as if walking with a citizen."[214] The artistic upswing in Rome seemed to confirm the universal historical principle "that it was freedom, through which art was lifted."[215] As far as the Villa Albani tried to compete with the Villa Hadriana, it must have seemed like a test to Winckelmann, whether or not the present was powerful enough to reattain the level of the Greeks—in the arts as in politics. A quarter of a century after Hebenstreit had justified his concept of "socialization" of the collection inventories that like and like always had to be placed together, sculpture of the antiquity, according to Winckelmann, expressed a "socialization" in a stylistic, historical, and political sense.

Via this sense-embracing context, Winckelmann was responding to the reduction of Cartesian thought on the basis of utility that had accompanied the triumphal march of the large factory and early industrialization. In the very first sentence of *History of Ancient Art,* Winckelmann offered an almost mocking reply to utilitarian thought, which had exploded the link between art and technology in the name of the superiority of mechanics. He wrote that "the arts, which are dependent on the illustration, have started with that which is necessary, as do all inventions; then one seeks beauty, and finally comes that which is unnecessary and useless. These are the three most sophistocated levels of art."[216] Utility as a prerequisite for beauty is thus forced into a subordinate role. Winckelmann was strengthened in this respect by authors such as the philosopher Hermann Samuel Reimarus (1694-1768), whom he mentioned in July 1764 with deep respect.[217] In 1754, Reimarus had prepared a highly regarded reckoning with mechanistic philosophy. Therein, the world of the machine was seen as a sphere of forced movements whose purpose never lies in itself, but alone with regard to humanity: "And so the Vaucanssonian man plays not for his own ears; the periscopes and magnifying

glasses make nothing of their own face visible; the best clocks strike and show not themselves the time." For Reimarus, the image of nature as a "monstrous machine" with "no eye that sees, observes, researches" became a vision of a "henceforth dreadful and horrible world."[218]

Correspondingly, Winckelmann and his Roman contemporaries saw everything even remotely reminiscent of mechanical or technical force as the epitome of lifelessness as well as stylistic aberration. That which is threatening in forced movement causes the artistic ideal of creating the illusion of artificial movement up to optical illusions to lose its *raison d'etre*. Winckelmann's rejection of artists such as Lorenzo Bernini, Pierre Puget and François Girardon can be understood as a counter-reaction to all attempts to imitate constrained and forced movement. Even Michelangelo's figures on the graves of the Florentine Medici "have such an unusual position, that life must exert force upon itself in order to remain lying."[219] In the same sense, the painter Anton Raphael Mengs (1728-1779), a friend of Winckelmann, rejected Baroque works as art of *"Macchinisti."*[220] True "grace," on the other hand, is dependent "on the right degree of ease, far from constraints and sought out wit."[221]

Winckelmann's *History of Ancient Art* marked a major break. It demonstrated that the sculpture of antiquity was freed from any correspondence with mechanics, thereby bursting both the unity of art and technology and the chain connecting the links of **natural formations – ancient sculptures – works of art – machines.** This loss is transformed by the new function of art to embody the ideal relationship of humanity to the climatic, that is the natural, as well as to the second, political nature; this thus put a seal on its superiority. Accordingly, the universal aspect of recording the world in the *Kunstkammer* changed into the assumption that aesthetics can be used to conclude the whole of history and society.

The consequences were as serious as they were lasting. Liberated into the freedom of purposelessness, art rose to the

crown and goal of all human activity. An initial effect was that Winckelmann's equation of classicism and republican freedom had a decisive influence on the treatment of art during the French Revolution. Jacques Louis David, who had encountered Winckelmann's theories while in Rome from 1775 to 1780, contributed to this effect. In his efforts to reorganize the artistic administration of the Louvre in 1793-94, he suggested Casimir Varon for a position on the conservatorium staff. He justified his proposal with the argument that Varon was working on a continuation of Winckelmann's *Monumenti inediti* and in 1795, Winckelmann's *History of Ancient Art* was praised before the national convention as a "masterpiece."[222] It is a less known fact that Thomas Jefferson, who later became the third US-American president, was a legate in Paris at the time, and he developed his own concept of art in this climate of revolutionary classicism. He obtained a copy of *History of Ancient Art* and his friend, Charles-Louis Clérisseau, must have supplied him with additional details. Winckelmann had instigated his close friend Clérisseau's participation in the designing of the Villa Albani. When Jefferson commissioned the construction of the Capitol Building in Virginia, the first significant state building of the US-American republic, its classicistic style could be traced through Clérisseau's archaeological research back to Winckelmann's ideas.[223]

The most important impact of Winckelmann's classical, republican concept of art that was at the same time freed from the realm of utility, was that it provided the basis for the theory of modern art museums. As a vessel of liberated humanity, the art museum took on the prestige in the course of the French Revolution that had been reserved up to that time for the *Kunstkammer* as an encyclopedic institution. After parts of the confiscated royal art was transferred to the *Grande Galerie* of the Louvre, the iconoclasm of terror was shown that the works of art that had been held up to that point as slaves were thus liberated, as a crowning glory of the revolution. When the revolutionary army sent the first shipments of artworks from the

Netherlands to Paris in September 1794, even this foray was considered a liberation of the works of art themselves: "These works of famous men shall find their peace in the hearts of free peoples; the tears of the slaves are not worthy of their greatness, and the honor of the kings do nothing but disturb their peace. These immortal works shall no longer be in a foreign land; today they have arrived in the fatherland of the arts and the genius, liberty and equality, in the French Republic."[224]

The liberating pathos that Winckelmann had attributed to Greek art continued to have an effect in the Louvre. In the *"Musée des Monuments Français"* opposite from the Louvre, on the other hand, Winckelmann's principle of stylistic chronology was applied for the first time. Alexandre Lenoir, founder and curator of this museum, explicitly referred to Winckelmann, of whom he had a bust installed in the foyer, in prescribing this historical system of organization as the model for every later art museum: "The high regard that this man instilled in me, the recognition that artists have given him, this all has persuaded me to erect a monument in his honor."[225] Lenoir's gesture was by no means exaggerated. Winckelmann had contributed to transfer the *Kunstkammer's* claim to universality to works of the fine arts. As a result, modern art museums also took over the heritage of the *Kunstkammer* in a purified form. Despite their closeness to palaces, mausoleums, treasuries, and more recently department stores, museums up to the present day hide the laboratories of a counter-world. They provide an "asylum" for works of art[226] that develop their critical impetus in the exchange with other objects, through the insistence to preserve a sphere of visual sensory stimulus that extends beyond the world of utility.

A no less profound effect was achieved by Winckelmann's dissimilar twin, Giovanni Battista Piranesi. Piranesi was just as obsessed with antiquity as Winckelmann, but at the same time that *History of Ancient Art* was written, he went a very different way. As an architect in search of work, Piranesi was especially hard hit by the standstill in Italy. He saw Rome less as freedom

in life than as stagnation of all productivity. Piranesi also stood in sharp contrast to his times, and he too saw antiquity as an escape. He did not wager on ancient Athens, however, but on the Roman counterpart; not on Greek democracy, but on Roman technology; not primarily on sculpture, but on architecture; not on the age of beauty, but on that of harsh and sublime necessity; and finally, not on the categorical subordination of utility by beauty, or a separation of art and technology, but on a concept of beauty that is subordinate to utility and which follows the instructions of technical achievements.

Piranesi had already prepared his anticipatory reply to Winckelmann's work in 1760, with the help of the dictum borrowed from Vitruvius that art is determined by *"Fermezza, utilità, belezza"* (firmness, utility, beauty).[227] Just as Winckelmann had reserved the intermediate position for "beauty," Piranesi put "utility" in its place, reading the valid form of beauty from the simple usefulness of functional buildings. In contrast to Winckelmann, Piranesi thus spoke out in favor of the advocates of utility, but not in order to exclude art from the series of valuable activities; instead, he intended to reconcile art and technology, purpose and form in the sense of a reception of antiquity containing futuristic traits.

Piranesi's reconstructions of ancient Rome represent a new stage in the history of archaeology. In the sense of an early form of industrial archaeology, they offer deep insights into the construction of facilities of antiquity and are concerned with the technical conditions of the erection of the edifices rather than their decline. Piranesi always developed particularly bold perspectives whenever he directed his glance not to the aboveground surface, but the underground foundations. Engravings depicting even technical instruments from cranes to spring shackles (figs. 36, 37) are evidence of his basic interest for the megalomanic technology of the Romans. Reminiscent of natural sculptures described by Aldrovandi, the accompanying text ends with the remark that mighty stone blocks only crudely processed give the impression of being created "more by

Fig. 36: Ancient hoisting tools for the construction of Cecilia Metella's grave, Etching by Giovanni Battista Piranesi, in: Antichità Romane, 1748

Fig. 37: Ancient tools for the construction of Cecilia Metella's grave, Etching by Giovanni Battista Piranesi, in: Antichità Romane, 1748

100

Fig. 38: City wall of Cora,
Etching by Giovanni Battista Piranesi,
in: Antichità di Cora, 1764

Fig. 39: Construction of Blackfriar's Bridge in the year 1764,

Drawing by Robert Mylne, 1766,
Etching by Giovanni Battista Piranesi, London, British Museum

nature than by art."[228] By drawing on the concept of natural artworks, Piranesi shortened the historical four-linked chain that Winckelmann had burst.

The historical vanishing point of Piranesi's gigantic visions thus also lie deep in the early history of Rome in the 6th century B.C., when according to legend the Etruscan King Servius Tullius had the first city wall erected, sewage lines laid through the city, and the first prison built as a symbol of a relentlessly strict sense of justice. The reconstructions of this prison and the *Cloaca Maxima* that Piranesi prepared between 1760 and 1764 led to the analysis of a contemporary city wall, the *"Antichità di Cora"* (fig. 38), that Piranesi dramatized into a sort of Etruscan Stonehenge.[229] Just as Winckelmann transferred the political issue of a lofty style to the present day, Piranesi extended the problematic of technology into his own time by depicting a modern functional construction of a friend of his with as much meticulousness and imagination as ancient buildings and instruments (fig. 39).

Although no artist or engineer combined the intense lure of antiquity as strongly with the cult of the machine as Piranesi did, he was by no means a blind futurist. The second version of his *"Carceri,"* in which the people appear as insect-like attributes of gigantic architectures and mechanical devices, forms the dark background of his technological utopia. The pulleys, joists, levers, chains, and other building instruments such as huge flywheels (fig. 40) are the props of torture chambers.[230] The visions might at first appear to be a fantasy of a mechanistic worldview gone wild. Although Adam Ferguson's remarks on the problematic side of industrialization were not published until 1767, it cannot be ruled out that Piranesi might have already been familiar with the reports of his English friend. Since operation of machines demands mechanical activity that must be carried out automatically and without thought, Ferguson believed that "manufactures, accordingly, prosper most, where the mind is least consulted, and where the workshop may, without any great effort of imagination, be

Fig. 40: Giant flywheel in the prison,
Etching by Giovanni Battista Piranesi,
in: Carceri d'Invenzione, ca. 1760

considered as an engine, the parts of which are men."[231]

Winckelmann's call to imitate ancient sculpture and Piranesi's fixation on ancient technology form Siamese twins of progress that are inseparable and will continue to be interrelated, despite their occupying opposite poles. The German translation of William Bailey's magnificent work on mechanics *The Advancement of Arts* appeared in 1776, including a frontispiece by Munich copper engraver Georg Michael Weissenhahn that evokes antiquity as an Arcadian goal of modern

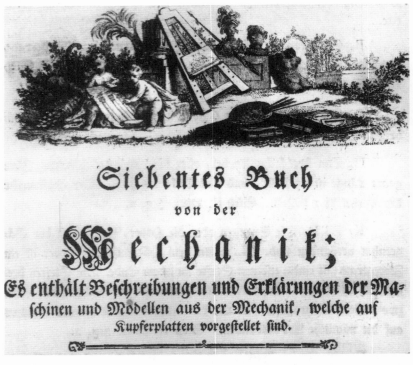

Fig. 41: The arts in Arcadia,
Copper engraving by Georg Michael Weissenhahn,
in: William Bailey, Die Beförderung der Künste, der Manufakturen
und der Handelsschaft, 1776

machinery (fig. 41).[232] The inreconcilability of the ancient idyll furnished with artistic tools, on the one hand, and with the aseptic detachment of machines, on the other, illustrates the isolation of technology from art, at the same time keeping alive the wish to bring the two together. Even after the separation of art and technics, according to the lesson of the frontispiece, the two realms continue to experience the division as not only a gain in autonomy, but also as a loss. For art, the loss is felt as a renouncement of responsibility and "life," and for technology, in its abandoning freedom and playfulness.

In *"Über das Marionettentheater"* (1810), Heinrich von Kleist

takes up the antithesis hypothesized by Winckelmann between the grace of statues of antiquity and the forced nature of constrained movement. A young man in front of a mirror was sitting by chance in the pose of the ancient "thorn remover" and unconsciously imitated its grace. When asked to repeat the pose, there seemed "an invisible and unfathomable force..., like an iron net, which diminished the free playfulness of his gestures."[233] Kleist's characterization of the artificiality of the movements once they became conscious is similar to the words with which Ferguson had described how the compulsion toward mechanical movement suppresses the consciousness. In the beginning of the nineteenth century, Dugald Stewart even spoke of factory workers as "living automatons."[234] As similar as the words sound, they still have different aims. Kleist was not concerned with observing the effects of industrialization, as has been continually referred to in literature since Jean Paul's *Unterthänigster Vorstellung* [1789, "Most Humble Presentation"]; rather, he offered a commentary on the fateful division of the ego into reason and emotion, and the lost of original grace. For him, it cannot be regained by returning to preconscious naturalness, but by advancing to the artificial grace of the marionette, suggestive of Plato's wire puppet simile.[235] In an unconventional manner, Kleist thus draws a final symbiosis of the lure of antiquity and the cult of the machine. The grace of ancient sculpture makes the modern individual painfully aware of the break. But it is consciousness itself which prevents a return to the ancient ideal through pure emulation. The free originality of antiquity can henceforth only be attained by futuristically and paradisiacally abandoning reflection, as represented by the unconscious grace of the marionette and the automaton-like wire puppet.

In E.T.A. Hoffman's *"Sandmann"* (1816),[236] all hopes of satisfying both the lure of antiquity and the cult of the machine are buried in a gruesome and ironic manner. The unlucky hero of the story falls in love with an "automaton," which drives him to a self-destructive state of madness. The automaton's name is "Olimpia."

AFTERWORD ON THE PRESENT

Foucault's Image in the Sand

T he tension-filled unity pulling both in the direction of
antiquity and that of machines had been broken. The
Kunstkammern nevertheless continued to convey their claim to
universality even beyond the realm of the art museum. There
were moments of an artistic comeback in the form of the meta-
physical rooms of Giorgio de Chirico, which were reminiscent
of collections. The rooms were filled with *mannequinos* in the
style of antiquity, thus preserving the tension between automa-
ton and ancient sculpture as reflected in the Cellini episode
mentioned at the beginning of this book. Max Ernst's *Histoire
Naturelle* was also indebted to the same *pensée sauvage* that had
provided the conceptual catalyst for the *Kunstkammer*.[237]
Reflections of the thought expounded through the *Kunst-
kammer* have remained alive in the history of style, in psycho-
analysis, and in iconology—that is, in everything expressing
the knowledge that playfulness is a necessary prerequisite for
the mind to be creative and that the essence, the inner core of
an effort or a person, has not remained intact in the center or in
a linear path to that center, but in free, concomitant phenome-
na void of obvious purpose.[238]

In contrast to these traditional cords, which are strength-
ened in light of the analysis presented here, other patterns of
thought are to be questioned. Among others, this includes
Michel Foucault's *Archaeology of the Human Sciences*. It closes
with the option that "man would be erased, like a face drawn
in sand at the edge of the sea."[239] Foucault's analysis is based
on the early modern age systems of collecting and organizing
and it is precisely these that do not support his neo-Baroque
turn to the subject of transitoriness. They do not demonstrate
that the dissolution of the relationship of natural objects to

human beings and the "exploding" of that very human and semantic sense of the objects serve to relativize all that is human, making the end of humanity fathomable. Rather, these systems show that the visual structuring of the collections held an early key to the history of development, even before the objects were stripped of the meaning encasing them. Meaningfulness and development were not mutually exclusive and thus, at least from Foucault's historical perspective, the end of modern anthropology was not broached.[240]

His analysis is based on criticism of interpretive language which relegates all events and things to fiction. Its weakness lies in the fact that it sees visual experience as a preliminary step toward linguistic form and not as a medium in which language is embedded, both historically and anthropologically. By interpreting the collections as "books furnished with structures," Foucault measures that which is visual according to the standards of grammar.[241] But when the *Kunstkammern* brought different collected objects into a visual exchange with one another, they stressed the metamorphic potential of the materials. Especially since natural objects were mixed with works of art and technology, the historicity of the materials—and not an ahistorical logocentricity of linguistic nomenclature—was conveyed. The links in the collecting chain which connected Parmigianino's collector (fig. 3) and Mazarin's gallery (fig. 16) did not represent fixed points in the history of style, but particular moments in the development of the materials. The transformation of image-creating nature to art of antiquity and then to post-antiquity works of art and machines did not derive primarily from a need to separate in creating order, but from a desire to comprehend the transitions more precisely. The *Kunstkammern* did not offer merely a link between artifacts from historically, geographically, and ethnically foreign cultures and all realms of nature; they also provided an opportunity for experimentation in merging form and meaning, taking up a more recent characterization of the "seen and unseen."[242]

Turing's "tape"

Major's comparison of Adam's brain with a slate that was wiped clean after the Fall, but which was waiting until "something can be written upon it anew,"[243] was one of the most impressive metaphors of the *Kunstkammer*. This motif traces back to Plato's dictum of the soul as a growing cast that can be continually changed through new impressions, which was transformed in sepulchral art of the 15th century into an empty *tabula ansata* symbolizing the pure soul. As a white slate, it symbolized in manneristic art theory the creative inspiration encompassing all of human imagination of the *disegno*.[244] Bacon proposed an entire system of "slates" as the archive and pillar of human memory,[245] and Saavedra's *Book of the Prince* included a white canvas, symbol of an empty brain which education fills with knowledge and morals "in the same way as [things must be entered onto] a clean slate" (fig. 42); and Locke's "white paper" is also part of this tradition.[246]

Alan M. Turing's "Computable Numbers" (1936) offers an unusual new version of this metaphor. The image of an initially empty tape is gradually filled with squares.[247] This "tape," as a "slate" that is "played" with, has since become a central image in computer programming: "The programmer-god makes the world not once and for all but many times over again.... The universe proceeds like a program until it runs down or runs wild, and then the slate is wiped clean, and a new game is begun."[248]

One wonders whether this reference to a "slate" uses this metaphor by chance or deliberately. In any case, the similarity of the images is symptomatic; the fact that playful painting or writing upon an empty slate continues to exist in the world of computers shows that the 20th century has inherited the theoretical essence of the *Kunstkammer*. And when recent attempts to emulate biological evolution via computer, simulate the creation of new species, and select and order these from the countless number of options are seen as an attempt to "cross... the

Fig. 42: White canvas symbolizing the brain,
Illustration in: Didaco Saavedra Faxardo,
Abriss Eines Christlich-Politischen Printzens, 1700
[original Spanish edition, 1640]

divide between art and science to try to enrich both cultures,"[249] this can be traced back to the very unity of nature and artistic technology that was definitive for the *Kunstkammer* and which represented the transition from the second to the third class of natural history in Bacon's system of knowledge. Without consciously reiterating an old question, human art has once again become a model for the completion of nature's playful powers of evolution. The credibility of such concepts is therein neither confirmed nor refuted; but it shows that newest

forms of futurism have remained within the conventional reservoir of metaphors of art history and historical art theory.

No one wants to return to the deliberate chaos of the *Kunstkammer* as museums. But the boundaries between art, technology, and science are beginning to break down in a similar manner as has been demonstrated by the *Kunstkammer*. In view of this fact, their lessons of visual association and thought processes which precede language systems take on a significance which might even surpass their original status. Highly technological societies are experiencing a phase of Copernican change from the dominance of language to the hegemony of images. The *Kunstkammern*, which were based almost entirely on thought in and through images, teaches us that disciplines such as mathematics, linguistics, psychiatry, and neurobiology—to name a few examples of fields which increasingly use the analysis of associative images arising in either a "chaotic" or controlled manner—would remain blind if they were to ignore the masses of historic materials supplied by art history.[250] The world of digitalized images cannot begin to be understood without knowledge of art history. And art history in turn now faces perhaps its most significant challenge in its more than four-hundred-year history. It can face this task of the future in its certainty that the *Kunstkammer* once existed.

Notes

1. Benvenuto Cellini, La Vita, II/XLI, in: ——, *Opere*, ed. Bruno Maier (Milan 1968): 470-473; here, cited according to the German trans. by Heinrich Conrad, *Das Leben des Benvenuto Cellini* (Stuttgart 1909): 189-192. Cf. Alexander Perrig, *Michelangelo Studien IV. Die "Michelangelo"-Zeichnungen Benvenuto Cellinis* (Frankfurt/M. 1977): 37.

2. Copper engraving by Madeleine Cochin, from a drawing by her son, 16-year-old Charles-Nicolas Cochin, cited in: Samuel Rocheblave, *Charles-Nicolas Cochin. Graveur et Dessinateur* (Paris, Brussels 1927): 73.

3. Voltaire, Sixième discours sur la nature de l'homme, in: ——, *Mélanges*, ed. Emmanuel Berl (Dijon 1961): 235. Cf. André Doyon and Lucien Liaigre, *Jacques Vaucanson. Mécanicien de Génie* (Paris 1966): 49ff; Hans Stöcklin, *Leitbilder der Technik. Biblische Tradition und technischer Fortschritt* (Munich 1969): 79.

4. Julien Offray de La Mettrie, *L'Homme machine*, ed. Gérard Delaloye (Utrecht 1966): 145; cf. Arno Baruzzi, *Mensch und Maschine. Das Denken sub specie machinae* (Munich 1973): 79ff.

5. Alfred Chapuis and Edmond Droz, *Les Automates des Jaquet-Droz* (Neuenburg, Switz., n.d.).

6. Herbert Beck et al., eds., *Antikensammlungen im 18. Jahrhundert* (Berlin 1981).

7. Johann Wolfgang von Goethe, *Dichtung und Wahrheit* [Poetry and Truth], in: *Goethes Werke*, ed. Erich Trunz (Munich 1978), IX: 501.

8. Ibid.: 502.

9. Etienne Bonnot de Condillac, *Traité des sensations* [1754] (Tours 1984), chap. 4/9, p. 266; here, cited according to the German trans. by Eduard Johnson and Lothar Kreimendahl, *Abhandlung über die Empfindungen* (Hamburg 1983): 214.

10. Andreas Blühm, *Pygmalion. Die Ikonographie eines Künstlermythos zwischen 1500 und 1600* (Frankfurt/M., etc. 1988): 108f.

11. Wolf Lepenies, *Das Ende der Naturgeschichte. Wandel kultureller Selbstverständlichkeiten in den Wissenschaften des 18. und 19. Jahrhunderts* (Frankfurt/M. 1978): 41ff.

12. Immanuel Kant, *Von den verschiedenen Racen der Menschen* [On the different races of man], 3, note 1, in: ——, *Gesammelte Schriften*, ed. Königlich Preußische Akademie der Wissenschaften (1905/12), II:434.

13. Julius von Schlosser, *Die Kunst- und Wunderkammern der Spätrenaissance. Ein Beitrag zur Geschichte des Sammelwesens* (2nd ed. 1923, Braunschweig 1978). Studies on this form of collection have not decreased in frequency since this time; on the contrary, such research has intensified considerably in

recent years. Cf. for an ambitious attempt at an authentic reconstruction, Joy Kenseth, ed., *The Age of Marvelous* (Hood Museum of Art, Dartmouth College, Hanover, NH, 1991); cf. for the Netherlands, *De* wereld *binnen handbereik. Nederlandse kunst- en rariteitenverzamelingen 1585-1735*, exhibition catalogue, 2 vols. (Amsterdam 1992); cf. for a comprehensive and complex picture of natural history collections in France, organized according to materials and individual collectors, Antoine Schnapper, *Le Géant, la Licorne et la Tulpie. Collections et Collectionneurs dans la France du XVII^e Siècle*, vol. I, Histoire et histoire naturelle (Paris 1988). Cf. for an earlier work written from a primarily Italian perspective, Adalgisa Lugli, *Naturalia et Mirabilia. Il Collezionismo Enciclopedico nelle Wunderkammern d'Europa* (Milan 1983).

14. Cf. on Leonardo's idea of sun and light as the source and aim of all movement, Joachim Otto Fleckenstein, *Leonardo nella Scienza e nella Tecnica, Atti del Simposio Internazionale di Storia della Scienza*, 23-26 June 1969, (n.p. 1975): 30-35.

15. Ulisse Aldrovandi, *Delle statue antiche, che per tutte Roma, in diversi luoghi, e case si veggono* (Venice 1562; reprint Hildesheim/New York 1975).

16. Ulisse Aldrovandi, *Musaeum Metallicum* (Bologna 1648): 746-779, here: 775. Cf. on Aldrovandi, Michel Foucault, *The Order of Things: An Archaeology of the Human Sciences* (London 1970): 128ff; and Jurgis Baltrusaitis, *Imaginäre Realitäten. Fiktion und Illusion als produktive Kraft* (Cologne 1984): 75. Cf., for general information on chance images in nature, ibid.: 55ff, and Horst Woldemar Janson, "Chance Images," in P.P. Weiner, ed., *Dictionary of the History of Ideas: Studies of Selected Pivotal Ideas* (1973), I:340-353, and Lugli (see note 13): 104ff.

17. Michele Mercati, *Metallotheca, opus posthumum opera studio Joannes Mariae Lanciscu illustratum* (Rome 1717): 24-25, 27. Cf. on the included copper engravings by Anton Eisenhoit, produced between 1578 and 1585, Anna Maria Kesting, *Anton Eisenhoit, ein westfälischer Kupferstecher und Goldschmied* (Münster 1964): 56-59; and Gisela Luther, "Stilleben als Bilder der Sammelleidenschaft," in *Stilleben in Europa*, exhibition catalogue (Münster and Baden-Baden 1980): 88-128, here: 110f.

18. Turin, Archivio di Stato, Cod.a.III.14.J.12, fol. 287r; on *"museum:"* fol. 229r, 230r-231r. Ligorio and Mercati must have encountered each other very often, at least during the time Ligorio served as site manager at St. Peter. Cf. on the *Ornithon*, Marcus Terrentius Varro, *Rerum Rusticarum*, III: 5, 9f.

19. Alexander Perrig, "Masaccios *'Trinità'* und der Sinn der Zentralperspektive," in: *Marburger Jahrbuch für Kunstwissenschaft*, (1986), 21: 11-43, here: 18f, 27.

20. Arundel Castle; cf. on the portrait of the earl, O. Ter Kuile, Daniel Mijtens, "His Majesties Picture-Drawer," in *Nederlands Kunsthistorisch Jaarboek* (1969), 20: 1-106, here: 43ff.; David Howarth, *Lord Arundel and his Circle* (New Haven, CT and London 1985): 57ff.

21. Cf. on the concept of a "picture within a picture," Martin Warnke, "Italienische Bildtabernakel bis zum Frühbarock," in *Münchner Jahrbuch der bildenden Kunst* (1968), 19: 61-102; cf. on the tradition surrounding such relics, Wilhelm Sebastian Heckscher, *Die Romruinen. Die geistigen Voraussetzungen ihrer Wertung im Mittelalter und in der Renaissance*, PhD dissertation Hamburg (Würzburg 1936): 26ff.

22. Cited here according to the second edition: Jacques Besson (Iacobus Bessonus), *Theatrvm Instrvmentorvm et Machinarvm* (Lyon 1578), fig. 30.

23. Lucius Caecilius Firmianus Lactantius, *Epitome Divinarum Institutionum*, in: Migne PL, VI/1, col. 1033. Cf. Reinhard Steiner, *Prometheus. Ikonologische und anthropologische Aspekte der bildenden Kunst vom 14. bis zum 17. Jahrhundert* (Munich 1991): 29f; and Olga Raggio, "The myth of Prometheus: Its survival and metamorphoses up to the eighteenth century," in *Journal of the Warburg and Courtauld Institutes* (1958), 21: 44-62.

24. Caius Plinius Secundus, *Naturalis historia*, XXXIII, 4, 8; XXXVII, 1, 2. Cf. Raggio (see note 23): 50-53.

25. *Schedelsche Weltchronik* (1493, reprint Grünwald near Munich 1975), XXVIII.

26. The thumb and first two fingers have been restored, though they closely resemble the original form. Even if they were added arbitrarily, however, the characteristic of the collector and merchant Imhoff that is mentioned here would support the context discussed. Cf. *Der Mensch um 1500. Werke aus Kirchen und Kunstkammer*, exhibition catalogue (Berlin 1977): 51, 53.

27. Giulio Camillo, *L'Idea del Theatro* (Florence 1550): 79-81. New ed.: Lina Bolzoni, ed. (Palermo 1991): 166-170. Cf. Richard Bernheimer, "Theatrum Mundi," in *The Art Bulletin* (1956), 28: 225-247, here: 225-231; Frances A. Yates, *The Art of Memory* (London 1972): 141ff; *Architettura e Utopia nella Venezia del Cinquecento*, exhibition catalogue (Venice 1980): 209ff; Steiner (see note 23): 179f; Lugli (see note 13): 77ff.

28. Cf. on the *studiolo*, Scott Jay Schaefer, *The studiolo of Francesco I de'Medici in the Palazzo Vecchio in Florence*, PhD dissertation Bryn Mawr College 1976 (Ann Arbor, MI 1976); and Marco Dezzi Bardeschi, et al., *Lo Stanzino del Principe in Palazzo Vecchio. I concetti, le immagini, il desiderio*, exhibition catalogue (Florence 1980). Cf. on the revision of the order reconstructed here, Michael Rinehart, "A Document for the Studiolo of Francesco I," in *Art the Ape of Nature: Studies in Honor of Horst Woldemar Janson*, ed. Moshe Barash and Lucy Freeman Sandler (New York 1981): 275-289. Vincenzo Borghini, "Inventione," in Karl Frey, *Der literarische Nachlaß Giorgio Vasaris* (Munich 1930), II: 886-91, cited here from: Wolfgang Liebenwein, *Studiolo. Die Entstehung eines Raumtyps und seine Entwicklung bis um 1600* (Berlin 1977): 155f. Steiner's theory that Prometheus first took on his role as a "god of progress" in the 18th century is qualified against the background of the history of collecting; Steiner (see note 23): 181.

29. *Mazarin. Homme d'Etat et Collectionneur 1602-1661*, exhibition catalogue (Paris 1961), cat. no. 447.

30. Jean Baudoin, *Iconologie, ov Explication novvelle de plvsievrs images...* (Paris 1644): 118 (fig., p. 113); cf. Klaus Maurice, *Die französische Pendule des 18. Jahrhunderts. Ein Beitrag zu ihrer Ikonologie* (Berlin 1967): 5ff.

31. Christiaan Huygens, *Horologium oscillatorium*, ed. and trans. K.E. Becker (Düsseldorf 1977), afterword.

32. Diego de Saavedra Fajardo, *Idea de un príncipe político christiano* (Munich 1640); cited here from the anonymous trans: Didaco Saavedra Faxardo, *Abriss Eines Christlich-Politischen Printzens* (Jena and Helmstedt 1700), no. LVII, p. 732. Cf. on the clock metaphor in general, Maurice (see note 30): 25-49; Otto Mayr, *Uhrwerk und Waage. Autorität, Freiheit und technische Systeme in der frühen Neuzeit* (Munich 1987); and Jörg Jochen Berns, "'Vergleichung eines Uhrwercks, und eines frommen andächtigen Menschens.' Zum Verhältnis von Mystik und Mechanik bei Spee," in Italo Michele Battafarano, ed., *Friedrich von Spee, Dichter, Theologe und Bekämpfer der Hexenprozesse* (Trient 1988): 101-194.

33. Robert W. Scheller, "Rembrandt en de encyclopedische kunstkamer," in *Oud Holland* (1969), 84: 81-147; here: 128f. Cf. for a criticism of Schlosser's basic work on *Kunstkammern* (see note 13), Rudolf Berliner, "Zur älteren Geschichte der allgemeinen Museumslehre in Deutschland," in *Münchner Jahrbuch der bildenden Kunst*, n. s., (1928), V: 327-352, here: 351; Schaefer (see note 28): 90ff.; and Rotraud Bauer, "Die Kunstkammer Rudolfs II. in Prag. Ein Inventar aus den Jahren 1607-1611," in *Jahrbuch der kunsthistorischen Sammlungen in Wien* (1976), 72: XI-XXXVIII, here: XIII-XVI. Cf. for a collection of materials including far more than the subject of castles, Barbara Jeanne Balsiger, *The Kunst- und Wunderkammern: A Catalogue Raisonné of Collection in Germany, France and England 1565-1750*, PhD dissertation Pittsburgh 1970 (Ann Arbor, MI 1971).

34. Samuel Quiccheberg, *Inscriptiones vel tituli theatri amplissimi, complectentis rerum vniuersitatis singulas materias et imagines eximias...* (Munich 1565). Cf. on the reception of Camillo, Elisabeth M. Hajós, "References to Giulio Camillo in Samuel Quiccheberg's 'Inscriptiones vel tituli theatri amplissimi,'" in *Bibliothèque d'Humanisme et Renaissance* (1963), 25: 207-211. Cf. on the Munich Kunstkammer, Herbert Brunner, *Die Kunstschätze der Münchner Residenz* (Munich 1977), 17ff; and Lorenz Seelig, "The Munich Kunstkammer 1565-1807," in Oliver Impey and Arthur MacGregor, eds., *The Origins of Museums: The Cabinet of Curiosities in Sixteenth- and Seventeenth-Century Europe* (Oxford 1985): 76-89. Cf. also the recent work of Harriet Hauger, "Samuel Quiccheberg: 'Inscriptiones vel tituli theatri amplissimi.' Über die Entstehung der Museen und das Sammeln," in Winfried Müller, et al., eds., *Universität und Bildung. Festschrift Laetitia Boehm zum 60. Geburtstag* (1991): 129-139.

35. On the other hand, the isolation of ancient arts in a separate antiquarium established starting in 1569 was in no way in keeping with Quiccheberg's ideas. Duke Albrecht, in acquiring the Fugger collections in addition to numerous other acquisitions, had suddenly found himself in possession of another comprehensive collection of ancient artifacts, necessitating the construction of a building to house the collection. The reasons were physical ones of space and not conceptual, as is apparent from the very hesitating process in which the ancient works were removed from the central building (Renate von Busch, *Studien zu deutschen Antikensammlungen des 16. Jahrhunderts*, PhD dissertation (Tübingen 1973): 115ff. Cf. also: Horst H. Stierhof, "Zur Baugeschichte des Antiquariums," in *Das Antiquarium der Münchner Residenz*, Ellen Weski and Heike Frosien-Leinz, eds., 2 vols. (Munich 1987), text vol.: 18-22.

36. Copper engraving by Matthäus Merian, in: *Topographia provinciarum Austriacarum* (Frankfurt/M. 1649), text sheet eI-eII. Corresponding to the special preference of the Archduke, the first of the four museum tracts included armaments in addition to trophies and costumes of adversaries, from the Turks among others. The last wing housed a special armarium, the "armament cabinet of the heroes," in addition to a library and an antiquarium. The ancient works from Ambras, together with the armaments, probably took on panegyric qualitities, so that in this case they should not be included in an analysis from a natural history perspective (Busch [see note 35]: 104).

37. Inventory of the estate of Archduke Ferdinand in Ruhelust, Innsbruck and Ambras, 30 May 1596, in: *Jahrbuch der Kunsthistorischen Sammlungen des Allerhöchsten Kaiserhauses* (1888), VII/2: CCLXXIX-CCCIII and (1889), X: I-X. Cf. *Die Kunstkammer, Führer durch das Kunsthistorische Museum*, no. 24, (Vienna, Innsbruck 1977); Elisabeth Scheicher, *Die Kunst- und Wunderkammern der Habsburger* (1979): 73-136; and Elisabeth Scheicher, "The Collection of Archduke Ferdinand II at Schloss Ambras: Its Purpose, Composition and Evolution," in *Origins* (see note 34): 28-38. Cf. for basic information on the history of the collection inventory, Thomas Ketelsen, *Künstlerviten Inventare Kataloge* (Ammersbek near Hamburg 1990): 101ff.

38. Scheicher (see note 37, *Collection*): 33. The small box of writing utensils, originally stored in Ambras and now in Vienna, is especially impressive; cf. *Wenzel Jamnitzer und die Nürnberger Goldschmiedekunst 1500-1700*, exhibition catalogue (Nuremberg 1985), no. 21, pp. 226f.

39. Bauer (see note 33): XIII-XVI.

40. Rotraud Bauer and Herbert Haupt, eds., Das Kunstkammerinventar Kaiser Rudolfs II., 1607-1611, in: *Jahrbuch der kunsthistorischen Sammlungen in Wien* (1976), vol. 72. Of more recent literature, in addition to Bauer (see note 33), see especially: Thomas DaCosta Kaufmann, "Remarks on the Collections of Rudolf II: the *Kunstkammer* as a Form of *Representatio*," in *Art Journal* (1978), XXXVIII: 22-28; Georg Kugler, "Rudolf II. als Sammler," in *Prag um*

1600. Kunst und Kultur am Hofe Rudolfs II., exhibition catalogue (Essen 1988), 2: 9-21; Eliska Fucíková, "The Collection of Rudolf II in Prag," in *Origins* (see note 34): 47-53.

41. Bauer (see note 33): XIX, XXIX.

42. *Prag* (see note 40), vol. 1, cat. nos. 726-731

43. Cited in Bauer (see note 33): XIV.

44. Elisabeth Scheicher, "Kunstkammer," Introduction, in *Kunstkammer* (see note 37): 13-23, here: 19. Cf. on the collecting of American *exotica* in Kunstkammern, J. Miguel Morán and Fernando Checa, *El colleccionismo en España. De la cámara de maravillas a la galería de pinturas* (Madrid 1985): 129ff.; and Christian F. Feest, "Spanisch-Amerika in außerspanischen Kunstkammern," in *Kritische Berichte* (1992), 20/1: 43-58, including a bibliography of older literature.

45. Franz Adrian Dreier, "Die Weltschale Kaiser Rudolfs II.," in Karl-Heinz Kohl, ed., *Mythen der Neuen Welt. Zur Entdeckungsgeschichte Lateinamerikas*, exhibition catalogue (Berlin 1982): 110-120. Cf. on the worldwide conception of the Kunstkammer, Friedrich Polleroß, "'Joyas de las Indias' und 'Parvus Mundes.' Sammlungen und Bibliotheken als Abbild des Kosmos," in *Federschmuck und Kaiserkrone. Das barocke Amerikabild in den habsburgischen Ländern*, exhibition catalogue (Vienna 1992): 36-53.

46. Johannes Kepler to Michael Mästlin, 1/11 June 1598, in : ——, *Gesammelte Werke*, ed. and trans. Max Casper, (Munich 1945), XIII: 218-232, here: 222.

47. "Machina mundi artificialis", copper engraving, in: Johannes Kepler, *Prodromus Dissertationsum Cosmographicarum continens Mysterium Cosmographicum...* (Tübingen 1596), tab. III following. p. 24; cf. *Gesammelte Werke*, ed. Franz Hammer (Munich 1963) vol. VIII, tab. III following p. 48. Cf. J.V. Field, *Kepler's Geometrical Cosmology* (London 1988): 38ff.

48. "Scopus meus hic est, ut Caelestem machinam dicam non esse instar divinj animalis, sed instar horologii" (Johannes Kepler to Herwart von Hohenburg, 10 Feb. 1605, in: ——, *Gesammelte Werke* (1951), XV: 146. Cf. Ewa Chojecka, "Johann Kepler und die Kunst. Zum Verhältnis von Kunst und Naturwissenschaften in der Spätrenaissance," in *Zeitschrift für Kunstgeschichte* (1967), 30: 55-72, here: 56, 55ff.

49. Kepler to Elector Friedrich von Württemberg, 17 Feb. 1596 (see note 46): 50-54.

50. Kepler to Mästlin, 1/11 June 1598 (see note 46): 225. Cf. on the interaction of art, industrial technology, and automaton construction in Kepler's circle in Prague, Thomas DaCosta Kaufmann, "'Ancients and Moderns' in Prague: Arcimboldo's Drawings for Silk Manufacture," in *Leids Kunsthistorische Jaarboek* (1983 [1984]), II: 179-207.

51. Book of Wisdom, 11:21 *Jerusalem Bible*. Cf. *Mass, Zahl und Gewicht. Mathematik als Schlüssel zu Weltverständnis und Weltbeherrschung*, exhibition catalogue (Wolfenbüttel 1989). The standard work on this subject and for all questions of the Biblical justification of technology is still Stöcklein (see note 3): 68ff and passim.

52. Plato, *Timaeus*, 31b-36d. Cf. Friedrich Ohly, "Deus Geometra. Skizzen zu einer Geschichte der Vorstellung von Gott," in Norbert Kamp and Joachim Wollasch, eds., *Tradition als historische Kraft* (Berlin etc. 1982): 1-42, here: 6-14. Cf. on the Renaissance, Fritz Saxl, "Science and Art in the Italian Renaissance," in ——, *Lectures* (London 1957), I: 111-124, here: 114ff.

53. Henricus Monantholius (Henri de Monantheuil), *Aristotelis mechanica, Graeca, emendata, Latina facta, et Commentariis illustrata* (Paris 1599), Epistola Dedicatoria, p. a IIIr: "Mundus enim hic machina est, quidem machinarum maxima, efficacissima, firmissima, formosissima." Cf. on Monantheuil, Rejer Hooykaas, *Das Verhältnis von Physik und Mechanik in historischer Sicht* (Wiesbaden 1963): 11-16. Cf. in general, Eduard Jan Dijksterhuis, *Die Mechanisierung des Weltbildes* (Berlin etc. 1956). Cf. on the history of the clock, Gerhard Dohrnvan Rossum, *Die Geschichte der Stunde. Uhren und moderne Zeitrechnungen* (Munich 1992). Cf. on the clock metaphor, in addition to the already cited works by Mayr and Berns (see note 32), Klaus Maurice and Otto Mayr, *Die Welt als Uhr. Deutsche Uhren und Automaten 1550-1650*, exhibition catalogue (Munich 1980).

54. "Je ne reconnois aucune difference entre les machines *que font les artisans* les divers corps *que la nature seule compose*" (René Descartes, *Les Principes de la Philosophie*, IV/203, in: ——, *Œuvres*, ed. Charles Adam and Paul Tannery (Paris 1978), IX/2: 321.

55. Aldrovandi (see note 16): 767f.

56. Gaspard Grollier de Servière, *Recueil d'ouvrages curieux* (Lyon 1719), tab. III; cf. Klaus Maurice, *Der drechselnde Souverän. Materialien zu einer fürstlichen Maschinenkunst* (Zurich 1985): 113f.

57. Maurice (see note 56): 16. Cf. on the motif of the ruler as artist in general, Martin Warnke, *Hofkünstler. Zur Vorgeschichte des modernen Künstlers* (Cologne 1985): 297-302; cf. on wood turning, ibid.: 300.

58. Johann Daniel Major, *Kurtzer Vorbericht / betreffende D. Johann-Daniel Majors... Mvsevm Cimbricvm, oder insgemein so-genennte Kunst-Kammer* (Plön 1688), II, §4, p. 7; cf. Wolfgang Braungart, *Die Kunst der Utopie. Vom Späthumanismus zur frühen Aufklärung* (Stuttgart 1989): 147.

59. Johann Daniel Major, *Unvorgreiffliches Bedencken von Kunst- und Naturalien-Kammern ins gemein* (Kiel 1674), §5, p. A4v.

60. Ibid., §7, p. A4r.

61. Walter Hermann Ryff (Rivius), *Von rechtem verstand / Wag und Gewicht* (Nuremberg 1547), Dedication. Cf. Stöcklein (see note 3): 125 and in general

pp. 42ff. Cf. on this motif, Hans Blumenberg, *Der Prozess der theoretischen Neugierde* (Frankfurt/M. 1973): 196ff; and Frances A. Yates, *The Rosicrucian Enlightenment* (London and Boston 1972): 97f.

62. John Locke, *An essay concerning human understanding*, ed. Peter H. Nidditsch (Oxford 1975), here: II/I, §2 (15): 104.

63. Ibid., I/II, §15: 55.

64 Ibid., II/XI, §17: 163.

65. Lorenzo Legati, *Museo Cospiano Anesso A Quello Del Famoso Ulisse Aldrovandi E donato alla sua patria dall'illustrissimo Signor Ferdinando Cospi* (Bologna 1677); cf. on the process of combining the exhibitions, Paula Elizabeth Findlen, *Museums, collecting and scientific culture in early modern Italy*, PhD dissertation (Ann Arbor, MI 1989): 7ff.

66. Alfons Rehmann, *Die Geschichte der technischen Begriffe* fabrica *und* machina *in den romanischen Sprachen*, PhD dissertation (Münster 1935): 104ff; cf. Jörg Garms, "Machine, Composition und Histoire in der französischen Kritik um 1750," in *Zeitschrift für Ästhetik und allgemeine Kunstwissenschaft*, (1971), 16: 27-42. Cf. on *"macchine"* as movable works of art, Rudolf Preimesberger, "Obeliscus Pamphilius," in *Münchner Jahrbuch der bildenden Kunst* (1974), XXV: 77-162, here: 82ff.

67. Clément Pierre Marillier, *Nouveaux Trophées ou Cartouches représentant les arts et les sciences composés avec les attributs qui les caractérisent*, national library (Paris, n.d. [1762]).

68. Peter-Klaus Schuster, *Melencolia I. Dürers Denkbild*, 2 vols. (Berlin 1991), I: 333f.

69. Rainer Klibansky, Ernst Panofsky and Fritz Saxl, *Saturn und Melancholie* (London 1964): 390.

70. This background tends to reinforce the idea that Galileo Galilei's philippic against the *Kunstkammer* did not emerge from modern aspects of his thought, but from his anti-manneristic concept of art, which, absurdly, led him to reject Kepler's notion of elliptical orbits (Erwin Panofsky, "Galileo as a Critic of the Arts," in *Isis* [1956], 47: 3-15). Cf. on the pre-Cartesian view of the world as a *"gran macchina,"* Heribert N. Nobis, "Frühneuzeitliche Verständnisweisen der Natur und ihr Wandel bis zum 18. Jahrhundert," in *Archiv für Begriffsgeschichte* (1967), 11: 37-58, here: 38, 51.

71. New fields of research developed in this area after the works of Daniel P. Walker, *Spiritual and demonic magic: from Ficino to Campanella* (London 1958); and Frances A. Yates, *Giordano Bruno and the Hermetic Tradition* (London 1965). Cf. for an overview, Maria Luisa Righini Bonelli and William R. Shea, eds., *Reason, Experiment, and Mysticism* (New York 1975); and Christoph Meinel, ed., *Die Alchemie in der europäischen Kultur- und Wissenschaftsgeschichte* (Wiesbaden 1986).

72. Plato, *Timaeus*, 77c.

73. Ernst Kris and Otto Kurz, *Die Legende vom Künstler* (Vienna 1934): 72ff.

74. Karl Eusebius von Liechtenstein, "Architekturtraktat," in Vikto Fleischer, *Fürst Karl Eusebius von Liechtenstein als Bauherr und Kunstsammler (1611-1684)* (Vienna and Leipzig 1910): 195. Cf. on the author, Brita von Götz-Mohr, "Gedechtnis und Curiositet. Der Fürst als dilettierender Architekt und Sammler," in *Die Bronzen der Fürstlichen Sammlung Liechtenstein*, exhibition catalogue (Frankfurt/M. 1986): 67-73.

75. Report of a visitor in 1640, in: Ernst Kris, "Der Stil 'rystique.' Die Verwendung des Naturabgusses bei Wenzel Jamnitzer und Bernard Palissy," in *Jahrbuch der kunsthistorischen Sammlungen in Wien*, n.s., (1926), I: 137-208, here: 152.

76. Quiccheberg (see note 34), cl. III/insc. II, p. bijr: "Animalia fusa: ex metallo, gypso, luto, facticiaque materia qualicunque: qua arte apparent omnia viua: vt lacertae, angues, pisces, ranae, cancri, insecta, concha, quicquid eius generis est, quibus postremum coloribus fere' subuenitur, vt vera esse putentur."

77. Scheicher (see note 37, *Kunst- und Wunderkammern*): 126, 132.

78. Cf. on this dictum of Paolo G. Lomazzo, David Summers, *Michelangelo and the Language of Art* (Princeton, NJ 1981): 80ff; and recently, Peter Gerlach, "Zur zeichnerischen Simulation von Natur und natürlicher Lebendigkeit," in *Zeitschrift für Ästhetik und Allgemeine Kunstwissenschaft* (1989), XXXIV/2: 243-279; it includes an outstanding commentary on the development of this concept, up to William Hogarth's snakelike concept of beauty. Formulated in 1745, it is an attempt to summarize natural form, artistic form, lifelikeness, and movement.

79. Bauer and Haupt (see note 40), nos. 1909, 1913, 1917 (antlers); 1907 (rape scene); 1908, 1918 (Laokoön); 1970 (Mercury); 1965 (automaton). Cf. on the connection between scientific discovery in the natural sciences and internal torque, Herbert Beck, "Plädoyer für eine Museumsdidaktik," in *Aus hessischen Museen* (1975), 1: 23-32, here: 28f. Cf. on automaton landscapes, Braungart (see note 58): 134f.

80. Kris and Kurz (see note 73): 73-89; Verena Lily Brüschweiler-Mooser, *Ausgewählte Künstleranekdoten*, PhD dissertation (Bern 1969, Zurich 1973): 3-40; Françoise Frontisi-Ducroux, Dédale. *Mythologie de l'artisan en grèce ancienne* (Paris 1975): in particular 95-117. Cf. on the passing down of traditions, Otto Mayr, "Automatenlegenden in der Spätrenaissance," in *Technikgeschichte* (1974), 41: 20-32.

81. Reinhold Hammerstein, *Macht und Klang, Tönende Automaten als Realität und Fiktion in der alten und mittelalterlichen Welt* (Bern 1986).

82. "quales fuerunt quae apud antiquos Daedali simulachra automata apellata sunt, quorum Aristoteles meminit, Vulcani Daedali tripodes seipsos

mouentes, quos sponte sua in certamen prodiisse narrat Homerus, quos legimos in Hiarbae Gymnosophistae conuiuio seipsos motasse: aureasque statuas pincernarum structorum operam conuiuis praestasse (Henricus Cornelius Agrippa ab Nettesheim, *De occulta philosophia* (n.p. 1533), bk. II/1, p. i ii^r; cited from Karl Anton Nowotny, ed., reprint, (Graz 1967): 111.

83. John Wilkins, *Mathematical Magic: or, the Wonders that may be performed by Mechanical Geometry in two Books* [1648], cited in: *The Mathematical and Philosophical Works of the Right Rev. John Wilkins*, 2 vols. (London 1802, reprint 1970), II: preface, before p. 93.

84. Giovanni Pailo Lomazzo, *Trattato dell'Arte della Pittura, Scultura ed Architectura*, 3 vols. (Rome 1844), here: II/1, in: vol. I: 174f.

85. Bauer and Haupt (see note 40), nos. 2193-2196.

86. Horst Bredekamp, "Die Erde als Lebewesen," in *Kritische Berichte* (1981), 9: 5-37.

87. "Ne tenant aucune apparence ny forme d'art, d'insculpture, ni labeur de main d'homme" (Bernard Palissy, *Œuvres*, Anatole France, ed. [Charavay 1880, reprint Geneva 1969]: 82). Remaining quotations, pp. 95f., 98. Cf. on Palissy's alchemy, Wallace Kirsop, "The Legend of Bernard Palissy," in: *Ambix* (1961), 9: 136-154. Cf. also Kris (see note 75): 196.

88. Salomon de Caus, *Von Gewaltsamen bewegungen. Beschreibung etlicher, so wol nützlicher alß lustigen Machiner...* (Frankfurt/M. 1615), here: bk. I, preface, p. A iiiv. Cf. on de Caus: Reinhard Zimmermann, *Hortus Palatinus. Die Entwürfe zum Heidelberger Schlossgarten von Salomon de Caus* [1620], commentary volume (Worms 1986): 7-12.

89. de Caus, ibid., bk. I, problem XXIV, pp. 31r-32r.

90. Zimmermann (see note 88): 37ff. This also renders my 1981 interpretation invalid (see note 86, p. 536).

91. Ralf Töllner, *Der unendliche Kommentar. Untersuchungen zu Kupferstichen aus Heinrich Khunraths "Amphitheatrum Sapientiae Aeternae Solius Verae"* (Hanau 1609, Hamburg 1992).

92. Yates (see note 61): 77f.

93. Cf. on this and "grottos and gardens as museums without walls," Paula Elizabeth Findlen, "The Museum: Its Classical Etymology and Renaissance Genealogy," in *Journal of the History of Collections* (1989), 1/1: 59-78, here: 60-62; excerpt: 62.

94. Johann Valentin Andreae, *Fama Fraternitatis* (1614), *Confessio Fraternitatis* (1615), *Chymische Hochzeit: Christiani Rosencreutz. Anno 1459 (1616)*, Richard van Dülmen, ed., (Stuttgart 1976): 108. [Cf. also the 1690 English translation of the *Chemical Wedding* by Ezechiel Foxcroft, reprinted in Waite, A.E., *The Real History of the Rosicrucians* (London 1887): 99ff. and in Allen, Paul M., ed., *A Christian Rosenkreutz Anthology* (New York 1968): 67ff.—trans.]

95. Ibid.: 117; cf. Braungart (see note 58): 75f.

96. Yates (see note 61): 193-99; cf. R.F. Ovenell, *The Ashmolean Museum 1683-1894* (Oxford 1986): 1-30.

97. Cf. pp. lff of this book, on Prometheus; cf. in general, Luigi Salernno, "Arte, Scienza e Collezioni nel Manierismo," in *Scritti di Storia dell'Arte in Onore di Mario Salmi* (Rome 1963), III: 193-214.

98. Quiccheberg (see note 34), pp. C ivrff.

99. Schaefer (see note 33): 240ff; DeCosta Kaufmann (see note 40): 25.

100. Vitruvius, I, 1ff; I, vi, 4. Cf. Detlef Heikamp, "Zur Geschichte der Uffizien-Tribuna und der Kunstschränke in Florenz und Deutschland," in *Zeitschrift für Kunstgeschichte* (1963), 26: 193-268, here: 208.

101. Heikamp (see note 100): 216.

102. Ibid.: 199.

103. William Schupbach, "Some Cabinets of Curiosities in European Academic Institutions," in *Origins* (see note 34): 169-178, here: 169f.

104. Giorgio de Sepi, *Romani Collegii Societatis Jesu Musaeum Celeberrimum* (Amsterdam 1678). Cf. P. Conor Reilly, *Athanasius Kircher S.J., Master of a Hundred Arts 1602-1680* (Wiesbaden and Rome 1974): 145-155; *Universale Bildung im Barock. Der Gelehrte Athanasius Kircher*, exhibition catalogue (Rastatt and Karlsruhe 1981).

105. Ferdinandus de Marsilis (Luigi Ferdinando Conte de Marsigli), *Atti Legali per la Fondazione dell'Istituto delle Scienze, ed Arti Liberali* (Bologna 1728), III; cf. the dedication by Bernand de Fontenelle, *Œuvres* (Paris 1752), 6: 479-485.

106. Michael Hunter, "The Royal Society's 'Repository' and its Background," in: *Origins* (see note 34): 159-168, here: 159, 166.

107. *Histoire et Prestige de l'Académie des Sciences 1666-1966*, exhibition catalogue (Paris 1966): 26.

108. Maxime Préaud, "'L'Académie des sciences et des beaux-arts:' le Testament graphique de Sébastien Leclerc," in *Revue d'art canadienne. Canadian Art Review* (1983), X/1: 73-81, here: 74f.

109. Ferrante Imperato, *Dell'Historia Naturale di Ferrante Imperato...* (Naples 1599).

110. Tommaso Campanella, "La Città del Sole," in *Scritti scelti di Giordano Bruno e di Tommaso Campanella*, ed. Luigi Firpo, (Turin 1968): 405-464, here: 412ff;

111. Braungart (see note 58): 85.

112. Chojecka (see note 47): 61, 64.

113. Johann-Christian Klamt, "Der Runde Turm in Kopenhagen als Kirchturm und Sternwarte," in *Zeitschrift für Kunstgeschichte* (1975), 38: 153-170, here: 156ff.

114. Johannes Kepler, *Nova Astronomia*, in *Gesammelte Werke* (Munich 1937), III: 14:
> "Ergò animo lustrans tritos Erronibus orbes,
> Immanesque minas et hiantibus intervallis,
> Moenia, nec positis, Mundi ruitura, columnis;
> Dum causas nox atra premit, securaque veri
> Pruteno indormit sapientum turba Magistro:
> Aggredior fidens oneri succedere tanto,
> Et stabilire novis coeli laquearia transtris;
> Materiem Samius famosam, quinque figuras,
> Euclides Normam, Mentem dedit inclyta Pallas;
> Vranie ingeminans non uno interprete plausus
> Accinuit celebrem, successu laeta, triumphum."

[The passage cited in the text is a translation from the German: *Neue Astronomie*, trans. Max Caspar, (Munich and Berlin 1929): 16—trans.]

115. A broad range of possible models is discussed in Marcin Fabianski, "Iconography of the Architecture of ideal Musaea in the fifteenth to eighteenth Centuries," in *Journal of the History of Collections* (1990), 2/2: 95-134, here: 116ff.

116. Balsiger (see note 33): 571; Braungart (see note 58): 104f.

117. Francis Bacon, *New Atlantis*, in ——, *The Works*, ed. James Spedding, Robert Leslie Ellis, and Douglas Denon Heath, 14 vols. (London 1857-1874), III (1857): 125-166, here: 156, 164.

118. Ibid.: 165.

119. Francis Bacon, *Valerius Terminus. On the Interpretation of Nature*, in ——, *Works* (see note 117), III: 199-252, in particular 222f. Cf. Paolo Rossi, *Francis Bacon: From Magic to Science* (London 1968): 84ff, 128ff; Hans Blumenberg, *Der Prozess der theoretischen Neugierde* (Frankfurt/M. 1973): 194ff.

120. Braungart (see note 58): 103f.

121. Francis Bacon, *Distributio Operis*, in ——, *The Complete Essays of Francis Bacon* (New York 1963): 165-177, here: 173; cf. also in Latin, in ——, *Works* (see note 117), I (1857): 141.

122. Bacon, *The Essays or Councels*, in ——, *Works* (see note 117), VI (1861) §18: 417.

123. Bacon, *Gesta Grayorum*, in: —— *Works* (see note 117), VIII (1862): 329-342, here: 335. Cf. Gerard l'E. Turner, "The Cabinet of Experimental Philosophy," in *Origins* (see note 34): 214-222, here: 220. On the time reference to early drafts of a revolution of knowledge, cf. Wolfgang Krohn, *Francis Bacon* (Munich 1987), 23f.

124. Bacon, *Of the Proficience and Advancement of Learning Divine and Human*, in ——, *Works* (see note 117), III (1857), pt. III, bk. 2: 330; and in Latin: *De Augmentis Scientiarum*, I (1857) 413-837, II §2: 496.

125. Around 1580, Art historical museum in Vienna, Schloss Ambras collections, cat. no. 8329.

126. Roberto Zapperi "Arrigo le Velu, Pietro le Fou, Amon le Nain et autres Bêtes: Autour d'un Tableau d'Agostino Carrache," in *Annales Économies Sociétés Civilisations* (1985), 2: 307-327.

127. Ulisse Aldrovandi, *Monstrorum historia* (Bologna 1642): 16. On Bacon's interpretation of the monster, in general, cf. Katharine Park and Lorraine J. Daston, "Unnatural Conceptions: The Study of Monsters in Sixteenth- and Seventeenth-Century France and England," in *Past and Present* (1981), 92: 20-54, here: 43ff. On monsters, cf. William B. Ashworth Jr., "Remarkable Humans and Singular Beasts," in *Age* (see note 13): 113-144.

128. Bacon, *The New Organon*, Aphorisms, bk. 2, XXIX, Library of Liberal Arts (Indianapolis/New York 1960): 178.

129. Ibid.: 178.

130. Here Bacon takes up the ancient topos of experiment as torture; cf. Hartmut Böhme, "Gaia. Bilder der Erde von Hesiod bis James Lovelock," in *Terre – Repere – Terre / Erde – Zeichen – Erde* [etc.] (Hamburg 1992): 18-64, here: 40f.

131. Bacon, *Advancement* (see note 124) III/III, bk. 2: 333; cf. also *The New Organon* (see note 128): 95.

132. Bacon, *De Augmentis* (see note 124), I/II §2: 496: "Artificialia a naturalibus non Forma aut Essentia, sed Efficiente solummodo, differe." [This section was elaborated upon by Bacon in his Latin translation. The passage cited here did not exist in the original English version.—trans.]

133. Bacon, *De Augmentis* (see note 124), II §2: 496: "Libenter autem Historiam Artium ut Historiae Naturalis speciem constituimus"x [See explanation in note 132—trans.]

134. Bacon, *Advancement* (see note 124), III/III, bk. 2: 331.

135. Prov. 8:30-31 *Jerusalem Bible*; "Cum eo [=deo] eram, cuncta componens. / Et delectabar per singulos dies, / Ludens coram eo omni tempore, / Ludens in orbe terrarum; / Et deliciae meae esse cum filiis hominum."

136. Beda Venerabilis, Super Parabolas Salomonis Allegorica Exposito, in: *Migne Patrologia Latina*, 91 (1862), col. 966b. On the Hebrew, cf. Othmar Keel, *Die Weisheit spielt vor Gott*, (Freiburg/Göttingen 1974): 29f, 69f.

137. Plato, *Nomoi*, 803c, 804b, 7;cf. 644d,e.

138. Kaspar Schott, *Magia Optica, das ist: geheime doch naturmässige Gesicht- und Augen-Lehr*, (Bamberg 1671): 153; cf. Stöcklein (see note 3): 85.

139. "Haes atque talia ex hominum genere ludibria sibi, nobis miracula inge-niosa fecit natura" (C. Plinius Secundus the Elder, *Naturalis Historiae* [Roderich König und Gerhard Winkler, ed. and German trans.], Tusculum edition, (1975) VII: 32 (VII/II: 32). Cf. (1979), IX: 78 [IX, XXXIII: 102]; vol. XXI/XXII, 1985 (XXI, I, 1). Cf. Paula Findlen, "Jokes of Nature and Jokes of Knowledge: The Playfulness of Scientific Discourse in Early Modern Europe," in *Renaissance Quarterly* (1990), XLIII, 2: 292-331, here: 296. Linneaus also spoke of monsters as a "joke" of nature (Lepenies [see note 11]: 70, 173).

140. Leone Battista Alberti, *On Painting and on Sculpture – The Latin Texts of* De Pictura *and* De Statue (Cecil Grayson, ed.) (Oxford 1972), §1: 120. Cf. Horst Woldemar Janson, "The 'Image Made by Chance' in Renaissance Thought," in Millard Meiss, ed., *De Artibus Opuscula XL. Essays in Honor of Erwin Panofsky* (New York 1961), I: 254-266; and Baltrusaitis (see note 16): 55ff, whose statements are based on Leonardo da Vinci's similar remarks with respect to chance images on walls.

141. Plato, *Parmenides* 137b. On inspiration by contemporary games, cf. Wolfgang Breidert, "Rhythmomachie und Globusspiel. Bemerkungen zu zwei mittelalterlichen Lehrspielen," in *Mitteilungen und Forschungsbeiträge der Cusanus-Gesellschaft* (1973), 10: 155-171.

142. Nikolaus von Kues, *Vom Globusspiel*, German trans.: Gerda von Bredow, (Hamburg 1978), 2: 1.

143. Ibid., 45: 34.

144. Carolyn Merchant, *The Death of Nature. Women, Ecology and the Scientific Revolution* (London 1982): 186f.; on the other hand, cf. Yates, *Enlightenment* (see note 61): 118ff and Krohn (see note 123): 135ff, 173, on the methodologi-cally fragmentary and non-linear character of progress in Bacon's revolution of knowledge, and p. 165f on the ethical responsibility of researchers of "New Atlantis."

145. Bacon, *The New Organon* (see note 128), bk. 2, XXXI: 182.

146. Michael Maier, *Lusus serius* (Oppenheim 1616). Cf. Yates, *Enlightenment* (see note 61): 84f.

147. Thomas DaCosta Kaufmann, "Arcimboldo's Serious Jokes: 'Mysterious but Long Meaning,'" in Karl-Ludwig Selig and Elisabeth Sears, eds., *The Verbal and the Visual, Essays in Honor of William Sebastian Heckscher* (New York 1990): 59-86.

148. Ambroise Paré, *Des monstres et prodiges*, Jean Céard, ed., (Geneva 1971): 139; cf. Park and Daston (see note 127): 41.

149. Bacon, *The New Organon* (see note 128), bk. 2, XXXI: 181.

150. Braungart (see note 58): 16-81. On architecture, cf. Hanno-Walter Kruft, *Städte in Utopia. Die Idealstadt vom 15. bis 18. Jahrhundert* (Munich 1989): 79f.

151. Felix Emil Held (Engl. trans., intro., and historical background) *Christianopolis: An Ideal State of the Seventeenth Century* [Original: Johann Valentin Andreae, *Christianopolis*], (New York 1916), intro.; cf. Stöcklein (see note 3): 84-86, Braungart (see note 58): 70ff. On the religious content of Andreae's concept of play, cf. Harald Scholtz, *Evangelischer Utopismus bei Johann Valentin Andreae. Ein geistiges Vorspiel zum Pietismus* (Stuttgart 1957): 12-23. On the literary meaning, cf. Richard van Dülman, *Die Utopie einer christlichen Gesellschaft: Johann Valentin Andreae* (1568-1654) (Stuttgart 1978): 95-97. Cf. in general, also, Johan Huizinga, *Homo Ludens. Vom Ursprung der Kultur im Spiel* [1938] (Reinbek near Hamburg 1987); and Hugo Rahner, *Der spielende Mensch* (Einsiedeln 1952).

152. Andreae [Held] (see note 151), §47: 200-201.

153. Ibid., §48: 202-203.

154. Ibid., §44: 196-197.

155. Matthäus Merian, etching, in Robert Fludd, *Utriusque cosmi, majoris scilicet et minoris, metaphysica, physica atque technica historia*, (Oppenheim 1617), 1: 4-5. Cf. Wolfgang Kemp, Natur. Ikonographische Studien zur Geschichte und Verbreitung einer Allegorie, PhD dissertation (Tübingen 1973): 88f.

156. Schott (see note 138): 153; cf. Stöcklein (see note 3): 85.

157. Besson (see note 22), p. A2v. For additional examples, cf. Stöcklein (see note 3): 84ff.

158. De Caus (see note 88), dedication, n.p.

159. Athanasius Kircher, *Neue Hall- und Thonkunst / oder mechanische Gehaim-Verbindung der Kunst und Natur durch Stimme und Hall-Wissenschaft gestiftet...*, (Nördlingen 1684), preface, n.p.

160. Andreae [Held] (see note 151), §13: 156-158.

161. Daniel Guilelmus Mollerus, De Technophysiotameis, Von Kunst= und Naturalien=Kammern, PhD dissertation, (Altdorf 1704), II: 9.

162. "Hic enim orbem in domo, imo in Museaeo, id est microcosum seu rerum omnium rariorum Compendium": Pierre Borel, Les Antiquitez, Raretez, Plantes, Minéraux, autres choses considerables de la Ville et du Comté de Castres..., (Castres 1649): 132. Cf. Balsiger [see note 33]: 566; Krysztof Pomian, "Collection-Microcosme et la Culture de la Curiosité," in *Science Crededenze Occulte Livelli di Cultura* [Istituto Nazionale di Studi sul Rinascimento, ed.], (Florence 1982), 535-557, here: 535f; and Schapper [see note 13]: 231-235.

163. Major (see note 58), §14: 9.

164. Legati (see note 65): 20f; cf. Findlen (see note 139): 305, 309. Legati mentions "scherzar natura" at several places, including the chapter on fossils (pp. 164ff); the collector Cassiano dal Pozzo, who had similar natural and art historical interests, used the same term (David Freedberg, "Ferrari on the Classification of Oranges and Lemons," in Elisabeth Cropper et al, eds., *Documentary Culture: Florence and Rome from Grand-Duke Ferdinando I to Pope Alexander VII* (Bologna 1992), 3: 287-306, here: 298). On the *"lusus naturae"* that already existed in the ordering of Aldrovandi's collection, cf. Giuseppe Olmi, *Giuseppe Aldrovandi. Scienza e natura nel secondo cinquecento* (Trient 1976): 79ff.

165. Olaf Worm, *Museum Wormianum* (Louvain 1655): 81; cf. Findlen (see note 139): 292.

166. Kaspar Schott, *Physica curiosa* (Würzburg 1697), II: 1362; cf. Findlen (see note 139): 313.

167. Bacon, *The New Organon* (see note 128), bk. 2: 121; on that and the concepts of *"natura naturans"* and *"fons emanationis,"* cf. Krohn (see note 123): 115f, 128.

168. Herbert Kieckmann, "Naturgeschichte von Bacon bis Diderot: Einige Wegweiser," in Reinhard Kosellek and Wolf-Dieter Stempel, eds., *Geschichte – Ereignis und Erzählung* (Munich 1973): 95-114, here: 98. Cf. also Braungart (see note 58): 98f.

169. Bacon (see note 117): 164.

170. Peter Frieß, "Rettung einer Automatenfigur," in *Uhren. Alte und moderne Zeitmessung* (1988), 4: 40-50; Adelheid von Herz, Androiden des 16. Jahrhunderts, master's thesis (Hamburg 1990). On automatons in Kunstkammer, cf. also: Moràn and Checa (see note 44): 207f.

171. Krohn (see note 123): 135ff, 147f.

172. Bacon, *The New Organon* (see note 128), bk. 2, XXXI: 180.

173. Bacon, *Of the Wisdom of the Ancients* in ——, *Works* (see note 117), VI (1858): 687-764, here: 698-9; and in Latin: *De Sapientia Veterum* in ——, *Works*, VI: 616-686, here: 628: "Sapientia prisci saeculi, aut magna aut felix fuit."

174. Thomas Tenison, *Baconiana* (London 1679): 57.

175. Bacon, *De Augmentis* (see note 124), I/II §4: 503f. Cf. Paul Authur Memmesheimer, "Francis Bacons Verhältnis zur Bildenden Kunst und seine Vorstellungen von einer Kunstgeschichte," in Kunsthistorisches Institut der Universität Bonn, ed., *Schülerfestgabe für Herbert von Einem zum 16. Februar 1965* (Bonn 1965): 165-171, here: 169.

176. Nikolaus Steno, De Solido Intra Solidvm Natvraliter Contento Dissertationis Prodromvs, 2 vols. (Berlin 1988); vol. I: Facsimile of the 1669 edition; vol. II: German trans. by Karl Mieleitner: 17-92; Eginhard Fabian, *Nicolaus Stenonis. Versuch einer Annäherung* (Berlin 1988): 93-171, here: 101, 111, 120, 120f, 128.

177. Robert Hooke, *The Posthumous Works*, Richard Waller, ed. (London 1705): 411. Cf. Francis C. Haber, "Fossils and Early Cosmology," in Bentley Glass, et al., eds., *Forerunners of Darwin: 1745-1859* (Baltimore 1968): 3-29, here: 27.

178. Ibid.: 335. Cf. Martin J.S. Rudwick, *The Meaning of Fossils: Episodes in the History of Palaeontology* (London/New York 1972): 74. On the connection between Descartes' historical view of the stars and the historicizing views of Steno and Hooke, ibid.: 76.

179. Thomas Burnet, *Theoria Sacra Telluris, d.i. Heiliger Entwurff oder Biblische Betrachtung des Erdreiches*, Johann Jacob Zimmermann, German trans. (Hamburg 1698), I/IV: 25f. [The passage was translated from the German translation of the Latin original. For an English translation from the Latin, which does not correspond entirely to the German, cf. Thomas Burnet, *The sacred Theory of the earth: containing an account of the original of the earth and of all the general changes which it hath already undergone, or is to undergo, till the consumation of all things*. (London 1690-91; reprinted with an introduction by Basil Willey, London 1965)—trans.]

180. Stephen Jay Gould, *Time's Arrow, Time's Cycle: Myth and Metaphor in the Discovery of Geological Time* (Cambridge MA/London 1987): 59.

181. Rüdiger Campe, Bezeichnen, Lokalisieren, Berechnen, manuscript, appeared in: *Der ganze Mensch. Anthropologie und Literatur im 18. Jahrhundert* (Stuttgart 1993). On Kant, cf. Andreas Heinreich Trebels, *Einbildungskraft und Spiel. Untersuchungen zur kantische Ästhetik* (Bonn 1967). Friedrich Schiller, *Über die ästhetische Erziehung des Menschen*, in ——, *Werke in Einzelausgaben* (Benno von Wiese, ed.), Gedichte, Prosa (Frankfurt/M. 1961), Briefe 14f, pp. 524-532.

182. Petrus Ramus, *Scholarum Mathematicarum* (Frankfurt/M. 1599): 101: "Verumenimvero Britanniam antea cohortati sumus, Germaniam laudavimus: Italia vero omni genere laudis cohortationis mihi complectanda est, artium praestantia ingeniorumque.... Habet Italia multas nobiles Academias, in quibus si suus honor mathematis habeatur."

183. Gottried Wilhelm Leibniz, *Zwei Plane zu Societäten* in ——, *Werke* (Onno Klopp, ed.), (Hannover 1864), series (Reihe) I/I: 109-148, here: 135. Cf. Ludwig Stockinger, *Ficta Respublica. Gattungsgeschichtliche Untersuchungen zur utopischen Erzählung in der deutschen Literatur des frühen 18. Jahrhundert* (Tübingen 1981): 100ff; Braungart (see note 58): 166ff.

184. Leibniz (see note 183): 135f.

185. Ibid.: 125.

186. Charles Perrault, *Parallèle des Anciens et des Modernes en ce qui regarde les Arts et les Sciences*, 4 vols. (Paris 1688-1697; photom. reprint Munich 1964) I: 76ff. [= 120].

187. Jakob Leupold, *Theatrum Machinarum Generale, Schau-Platz de Grundes mechanischer Wissenschaften* (Leipzig 1724), preface, pp. 3f.

188. Letter report of Georg Gustav von Völckersahm, 4 Nov. 1769, cited in: Rose-Marie Hurlebusch and Karl Ludwig Schneider, "Die Gelehrten und die Großen. Klopstocks 'Wiener Plan,'" in F. Hartmann and R. Vierhaus, eds., *Der Akademiegedanke im 17. und 18. Jahrhundert* (Bremen-Wolfenbüttel 1977): 63-96, here: 72.

189. Johann Beckmann, Anleitung zur Technologie, oder zur Kentniß der Handwerke, Fabriken und Manufacturen, vornehmlich derer, die mit der Landwirtschaft, Polizey und Cameralwissenschaft in nächster Verbindung stehn. Nebst Beiträgen zur Kunstgeschichte (Göttingen 21780): 10f.; on Beckmann, cf. Manfred Beckert, *Johann Beckmann* (Leipzig 1983); cf. also, Johann Beckmann Journal, vol. 1ff: 1986ff.

190. Beckmann (see note 189): 18.

191. Ibid., preface, p. a3v.

192. Johann Wolfgang von Goethe, *Tagebuch der italiänischen Reise* in *Tagebücher* [= Weimar edition, III/I], (Weimar 1887): 266.

193. Copper engraving, frontispiece to: A Succinct Description of that Elaborate and Matchless Pile of Art, Called the Microcosm..., anonymous, n.p., n.d., Paris, Bibliothèque National, Cab. des est., Le 64 fol.

194. Cited in: Maurice (see note 30): 44.

195. Helmut Grötzsch and Jürgen Karpinski, Dresden. Mathematisch-Physikalischer Salon (Leipzig 1978): 12f.; On the development as a whole, cf. Friedrich Klemm, *Geschichte der naturwissenschaftlichen und technischen Museen* (Munich 1973): 29ff.

196. Ketelsen (see note 37): 143.

197. Georges Louis Leclerc, Comte de Buffon, Allgemeine Historie der Natur nach allen ihren besonderen Theilen abgehandelt; nebst einer Beschreibung der Naturalienkammer Sr. Majestät des Königs von Frankreich mit einer Vorrede Herrn Doctor Albrechts von Haller, (Hamburg and Leipzig 1752), II: 4f.

198. Buffon (see note 197), (Hamburg and Leipzig 1750), I: 4f.

199. Carl Vogt, Zoologische Briefe. Naturgeschichte der lebenden und untergegangenen Thiere, für Lehrer, höhere schulen und Gebildete aller Stände, 2 vols. (Frankfurt/M 1851), cited in Lepenies (see note 11): 167. For a criticism of *naturalia* cabinets, ibid.: 57.

200. Wolf von Engelhardt, "Wandlungen des Naturbildes der Geologie von der Goethezeit bis zur Gegenwart," in Jörg Zimmermann, ed., *Das Naturbild des Menschen* (Munich 1982): 45-73, here: 48.

201. Carolus Linnaeus, *Lappländische Reise*, German trans., H.C. Artmann (Frankfurt/M. 1975): 89. Linnaeus clearly did not embody the crystal-clear sense of reason that his supporters attributed him with, as shown by his "Nemesis Divina;" a crude theory of retaliation attempting to bridge gaps

between events that have nothing to do with each other (Carolus Linnaeus, Nemesis Divina [Wolf Lepenies and Lars Gustafsson, eds.; Ruprecht Volz, German trans.], (Munich 1981). Cf. also Wolfgang Lepenies, "Naturgeschichte und Anthropologie im 18. Jahrhundert," in *Historische Zeitschrift*, (1980), 231: 21-41, here: 25ff.). [The passage cited here has been translated from the German; cf. also Carolus Linnaeus, *A Tour in Lappland* (1732), Jakob Edward Smith, trans. (London 1811)—trans.]

202. Carolus Linnaeus, *Museum Adolpho-Fridericianum...* (Holmiae 1746); ——, Museum S. ae R. ae M. tis Ludovicae Ulricae Reginae Svecorum, Gothorum, Vandalorumque... (Holmiae 1764); David Hultmann, *Instructiio Musei rerum Naturalium* (Uppsala 1753), in: Carolus Linnaeus, *Amoenitates Academicae; seu Dissertationes Variae...* (Stockholm 1756), III: 446-464

203. Carolus Linnaeus, Systema Naturae sive Regna tria Naturae... / Natur-Systema, oder in ordentlichem Zusammenhang vorgetragene Drey Reiche der Natur... (Johann Joachim Langen, German. trans.), Halle 1740, p. a3ᵛ [cf. also ——, *A General System of Nature, through the three Grand Kingdoms of Animals, Vegetables, and Minerals*, W. Turton, ed. (Gmelin, Gabricius, Willdenow, trans.), (London 1806)—trans.]

204. Johann Ernst Habenstreit, Museum Richterianum, continens Fossilia Animalia Vegetabilia... (Leibzig 1743): 18.

205. On the tradition, cf. Christian Hülsen, *Römische Antikengärten des 16. Jahrhunderts* (Heidelberg 1917): XI; on the character of the villa, cf., Steffie Röttgen, "Die Villa Albani und ihre Bauten," in Herbert Beck and Peter C. Bol, eds., *Forschungen zur Villa Albani. Antike Kunst und die Epoche der Aufklärung* (Berlin 1982): 59-122, here: 101; Elisabeth Schröter, "Die Villa Albani als Imago Mundi. Das unbekannte Fresken- und Antikenprogramm im Piano Nobile der Villa Albani in Rom," in *Forschungen* (ibid.): 185-299, here: 289; Bredekamp (ibid., see note: preface): 512.

206. Schröter (see note 205).

207. Carl Justi, *Winckelmann und seine Zeitgenossen*, 3 vols. (Cologne 1956), here: II: 158ff; and Schröter (see note 205): 287f.

208. Johann Joachim Winckelmann, letter of 4 Feb. 1758, in ——, letters, 4 vols. (Berlin 1952-1957), here: I: 324.

209. Agnes Allroggen-Bedel, "Die Antikensammlung in der Villa Albani zur Zeit Winckelmann," in *Forschungen* (see note 205): 301-380, here: 328.

210. Wolf Lepenies, "Johann Joachim Winckelmann. Kunst- und Naturgeschichte im achtzehnten Jahrhundert," in Thomas W. Gaehtgens, ed., *Johann Joachim Winckelmann 1717-1786* (Hamburg 1986): 221-237.

211. Johann Joachim Winckelmann, *Geschichte der Kunst des Alterthums* (Dresden 1764), I/1: 26. [The passages cited here and in the following have been translated from the German; cf. also ——, *The History of Ancient Art*. G. Henry Lodge, trans, 4 vols,. (Boston 1873) —trans.]

212. Ibid., II: 407.

213. Ibid., I/1: 28. As significant as such remarks were, Winckelmann's life in Rome can certainly not be regarded as an idyll in freedom; cf. Hellmut Sichtermann, "Winckelmann in Italien," in *Winckelmann* (see note 210): 121-160.

214. Winckelmann, letter of 4 Feb. 1758 (see note 208): 326. Cf. Max L. Baeumer, "Klassizität und republikanische Freiheit in der außerdeutschen Winckelmann-Rezeption des späten 18. Jahrhunderts," in *Winckelmann* (see note 210): 195-219, here: 197ff.; on the early history of the projection of the modern concept of freedom onto Athens or Rome, cf. Johannes Dobai, *Die Kunstliteratur des Klassizismus und der Romantik in England* (Bern 1974), I: 676-679.

215. Winckelmann (see note 211), II: 407.

216. Ibid.: 3.

217. Justi (see note 207), I: 52; Winckelmann (see note 208), III: 49.

218. Hermann Samuel Reimarus, *Abhandlungen von den vornehmsten Wahrheiten der natürlichen Religion* [1754], Hamburg 1791 (6th printing): 131f, 133; cf. Wilhelm Schmidt-Biggemann, *Maschine und Teufel* (Munich 1975): 90.

219. Johann Joachim Winckelmann, "Von der Grazie in Werken der Kunst," in ——, *Kleine Schriften. Vorreden. Entwürfe*, Walther Rehm, ed. (Berlin 1968): 157-162, here: 161.

220. Anton Raphael Mengs, "Della Composizione di Raffaello," in ——, *Opere*, Giuseppe Niccola d'AZara and Carlo Fea, eds. (Rome 1787): 119; cf. Garms (see note 66): 31.

221. Winckelmann (see note 219): 157.

222. Katharina Scheinfuss, *Von Brutus zu Marat: Kunst im Nationalkonvent 1789-1795* (Dresden 1973): 126, 188; cf. Baeumer (see note 214): 206ff.

223. Baeumer (see note 214): 212ff.

224. Jacques-Luc Barbier on 20 Oct 1794 before the National Assembly, in Gaston Brière, "La Peintre J.L. Barbier et les conquêtes artistiques en Belgique" (1794), in *Bulletin de la Société de l'Histoire de l'Art français* (1920): 204-210, here: 206; cf. Paul Wescher, *Kunstraub unter Napoleon* (Berlin 1976): 38.

225. Alexandre Lenoir, cited in: Günter Busch, "Die Museifizierung der Kunst und die Folgen für die Kunstgeschichte," in Peter Ganz et al, eds., *Kunst und Kunsttheorie 1400-1900* (Wiesbaden 1991): 219-229, here: 221f.

226. On the museum as an "asylum," cf: Busch (see note 225): 220.

227. Giovanni Battista Piranesi, *Della Magnificenza ed Architettura de'Romani* (Rome 1761), XXXVI, p. LIII; Vitruvius, De Architectura, I, III, 2; cf. also Norbert Miller, *Archäologie des Traums. Versuch über Giovanni Battista Piranesi* (Munich and Vienna 1978): 233ff.

228. "Fatte più dalla natura che dall'arte" (Giovanni Battista Piranesi, Antichità Romane de'Tempi della Repubblica e de'Primi Imperatori (Rome 1748), vol. III, pl. LIII; the tools: LIV). Cf. on the early history and persisting impact of this motif: Bruno Reudenbach, "Natur und Geschichte bei Ledoux und Boullée," in *Idea* (1989), VIII: 31-56, here: 46.

229. Giovanni Battista Piranesi, *Antichità di Cora* (Rome 1764), pl. I.

230. Giovanni Battista Piranesi, *Carceri d'Invenzione* (ca. 1760), pl. IX; cf. Hans Magnus Enzensberger, *Mausoleum* (Frankfut/M. 1975): 38; Horst Bredekamp, "Piranesis Foltern als Zwangsmittel der Freiheit," in Christian Beutler, et al, eds., *Kunst um 1800 und die Folgen. Werner Hofmann zu Ehren* (Munich 1988): 31-46.

231. Adam Ferguson, *An Essay on the History of Civil Society* (Edinburgh 1767; photom. reprint New York 1971): 280. Cf. on this complex, Karl Marx, *Das Kapital* [= Karl Marx and Friedrich Engels, *Werke*, vol. 23], (Berlin 1970), I: 383f., 443-450.

232. William Bailey, *The Advancement of Arts, Manufactures, and Commerce...* (London 1771), (German trans. ——, *Die Beförderung der Künste, der Manufakturen und der Handelsschaft*, Munich 1776).

233. Heinrich von Kleist, "Über das Marionettentheater," in ——, *Sämtliche Werke und Briefe* (Helmut Sembdner, ed.), 2 vols. (Munich 1961), 2: 338-345, here: 344.

234. Dugald Stewart, "Lectures on Political Economy," in ——, *Collected Works* (Edinburgh 1855), VIII: 318.

235. Wilhelm Blum, "Kleists Marionettentheater und das Drahtpuppen-gleichnis bei Platon," in *Zeitschrift für Religions- und Geistesgeschichte* (1971), XXIII: 40-49; Rüdiger Bubner, "Philosophisches über Marionetten," in *Kleist-Jahrbuch* (1980): 73-85; Rudolf Drux, *Marionette Mensch. Ein Metaphernkomplex und sein Kontext von E.T.A. Hoffmann bis Georg Büchner* (Munich 1986): 27ff, 178ff.

236. E.T.A. Hoffmann, "Der Sandmann," in ——, *Poetische Werke* (Berlin 1957), III: 3-44. Cf. Jochen Schmidt, *Die Geschichte des Genie-Gedankens in der deutschen Literatur, Philosophie und Politik 1750-1945*, 2 vols. (Darmstadt 1985), II: 19ff. Cf. also *Selected Writings of ETA Hoffmann*, Leonard J. Kent and Elizabeth C. Knight, eds. and trans., 2 vols., incl. *The Sandman* in vol. 1, Chicago 1969.

237. Monika Steinhauser, *Max Ernst. Dadamax* (Munich, Zurich 1979); cf. in general, Arturo Schwarz, "Der Surrealist als homo ludens," in Arturo Schwarz, ed., *Die Surrealisten*, exhibition catalogue (Frankfurt/M. 1989): 11-104; Werner Hofmann, "Stil- und Sprachgeschichte: Julius von Schlossers 'offenes System,'" in: *Merkur* (1992), 516: 253-257, here: 255. The Sprengel Museum in Hannover displayed an exhibition on the return of the *Kunstkammer* in the art of the 20th century: "Die Erfindung der Natur," 1994.

238. Giovanni Morelli based the modern conception of style analysis on the principle that the handwriting of artists is not so much to be found in areas where they are in command of their senses, but more likely where they unconsciously deal with things of secondary importance. In keeping with Morelli's method, Sigmund Freud developed psychoanalysis using playful and ephemeral expressions such as subconscious dreams, gestures, and slips of the tongue [Carlo Ginzburg, "Spurensicherung," in ——, *Spurensicherungen* (Berlin 1983): 61-96]. Aby Warburg's form psychology of the *"bewegten Beiwerk"* gave new significance to iconology; and the Mnemosyne Project was supposed to develop enlightened thought in associative images into a global standard [Martin Warnke, "Der Leidschatz der Menschheit wird humaner Besitz," in Werner Hofmann, Georg Syamken, Martin Warnke, *Die Menschenrechte des Auges. Über Aby Warburg* (Frankfurt/M. 1980): 113-186].

239. Foucault (see note 16): 387.

240. Cf. Schnapper's criticism developed on the basis of the materials (see note 13, p. 311).

241. Foucault (see note 16): 137.

242. Krzysztof Pomian, *Collectioneurs, amateurs et curieux, Paris, Venise: XVIe-XVIIIe siècle* (Paris 1987); German: *Der Ursprung des Museums. Vom Sammeln* (Berlin 1988): 43f.

243. See note 60.

244. Plato, *Theaitetos*, 191c; Aristotle, *De anima* III.4 = 429b-430a. On the tradition up to the Renaissance, cf. Andreas Tönnesmann, "Ein psychologisches Motiv bei Raffael," in Ewald Könsgen, ed., *Arbor anoena cornis. 25 Jahre mittellateinisches Seminar in Bonn 1965-1990* (Stuttgart 1990): 293-304. On mannerism, cf. Hans-Joachim Raupp, *Untersuchungen zu Künstlerbildnis und Künstlerdarstellung in den Niederlanden im 17. Jahrhundert* (Hildesheim 1984): 86f, 288f.

245. Bacon, *The New Organon* (see note 128), bk. 1, II: ll.

246. Didaco Saavedra Faxardo, *Abriss Eines Christlich-Politischen Printzens* (Jena and Helmstedt 1700), epigram II, pp. 13f. An initial German translation appeared in 1655. Cf. Rüdiger Klessmann, exhibition review: "Rembrandt. Der Meister und seine Werkstatt. Gemälde...," in *Kunstchronik* (1992), 45/9: 441-456, here: 447f. On Locke, see note 62.

247. Alan M. Turing, "On Computable Numbers, with an Application to the *Entscheidungsproblem*," reprint in Martin Davis, ed., *The Undecidable: Basic Papers on Undecidable Proportions, Unsolvable Problems and Computable Functions* (New York 1965): 116-151, here: 117. On a critique of the philosophical metaphors of this article, cf. Günter Ropohl, "Die Maschinenmetapher," in *Technikgeschichte* (1991), 58/1: 3-14, here: 6.

248. J. David Bolter, *Turing's Man: Western Civilization and Natural Man* (New York 1977): 187f.

249. Stephen Todd and William Latham, *Evolutionary Art and Computers* (London, San Diego, etc. 1992): 209f.

250. An attempt is undertaken in: Horace Barlow, Colin Blakemore, Miranda Weston-Smith, eds., *Images and Understanding. Thoughts about Images/Ideas about Understanding* (Cambridge, etc., 1990). Cf. the emphatic program piece by Barbara Maria Stafford, *Body Criticism Imaging the Unseen in Enlightenment Art and Medicine* (Cambridge, MA, London 1992), here esp. pp. xviii, 34-43, 477, which draws similar conclusions from an analysis of the 18th century as has been attempted here based on the *Kunstkammer*.

Index of Names